MW00453394

DEDICATION

I would like to dedicate this book to those who have struggled with me to become the leader, teacher, mother, and woman of God He has designed me to be.

The process of becoming the perfect me was not easy, but it was truly necessary. To my husband of thirty-five years, Apostle Randy Roberts, I thank you for your unconditional love and support in helping me complete this project. It has been a busy year, and yet we found the time to do one more thing. I love you so much. Yes, we survived. To my children Ashley (Xavier, Ian, Robert, Olivia, and Nathan), Megan, and Chelsea, I thank you for your support and your patience in my development process.

To my parents, siblings, family, friends, and Love House Ministries, we thank you for always being there for us, believing in us, and supporting us endlessly. We could not have asked for a better group of people to serve with in the Kingdom.

To my chief editors Brandon Parker, Davina Coleman, Dr. Jamie Singleton, Megan Roberts, Tamekia Judge, and Torrye Parker, I thank you so much for every comma, every "Take that out," for every "Well say that," and for believing in me. You are an amazing team, and I would not have done this without you. I love you, guys!

I say a special thank you to all my supporting staff Alesha McErvin, KaSundra B. Frye, and Koren Pope who helped me transcribe this series; without you, I would not have been able to complete this project. I love you so much for your endless hours of support, dedication, and commitment.

Thank you for now, until the next book in this series is ready.

Journal included for a time of reflection.

CONTENTS

INTRODUCTION

The hardest part about becoming you is knowing who you are from the inside out. In learning about who you are, you must identify your strengths as well as your weaknesses. It is impossible to grow without being able to understand and identify what makes you weak. You must be willing to ask yourself, "Am I really ready to learn who I am?"

This is the beginning process from the series Becoming the Perfect Me. As you journal your way through this process, I ask that you become transparent and honest all the way through. Please use the space provided throughout this book to write your thoughts, your reflections, and your answers. You will not be asked to share your answers as they are only for your internal building process in becoming the perfect you.

This book was a yearlong process developed from teachings that were inspired for personal development of women who are called with a purpose for living and not just surviving. The process in becoming the perfect me has been a long journey. I, like many of you, have grown up in a world where things appeared to be perfect for so many, but for me, it was a world full of flaws where I wish I could have been better. There are mistakes I wish I could do over, delays I could have taken advantage of but did not, and regrets. I grew up in the inner city, and I was the eighth of twelve children to parents who have been married for almost seventy years. I grew up in a large city where people only dreamed of becoming someone important, but rarely did. I lived in an area where the first person who went to college became the local advisor on how to become you and what you can do to be yourself. Although I grew up within a stable family environment with strong Christian convictions, I wanted more for myself, but what did I want?

When I was ten, while walking to school with my sister and brother, we were running late for school. There were not a lot of people out on the streets with us during this time. There was a man who stared at us from afar, and when we walked past him, he grabbed my sister's hat and told her to come and get it. She said, "Run!" As we began to run, I fell, and the man picked me up and held me close to him and would not let me go. When I looked into my sister's eyes, she stared back at me; her eyes said, "I can't help you."

He talked to her to convince her to come and get her hat from him. It was apparent that he didn't want me; he wanted her, but I was his pawn. My sister could

not help me or convince him to let me go, so she ran with my brother as fast as they could home to get help. By the time they returned, he had taken me away and out of view of the public. As the community hunted for me, I clung to the hope that someone would be on their way to get me soon. Afterall, I was only ten years old.

After a very long ordeal, I was finally returned to my family with no real physical scars to be noticed, but inside, I was now full of internal wounds. To survive, I had to develop a survival strategy within me that no one could identify. I wanted out of my life, out of my community, and away from the environment I grew up in because it was a constant reminder of what I survived but still suffered from internally. Although I had survived from the hands of a pedophile, I wasn't living anymore; I was only surviving until I could get away.

But what was I trying to get away from? I was not sure. To escape my internal battles, I became a perfectionist in every area of my life. I did this in hopes that, one day, greatness would allow me to escape. I became a master of creating a model that others would easily take notice of and become drawn to. I watched the behavior, character, success, and failures of other people to perfect my skills. I had become a student of the teacher called life. Since I did not want to fail at anything, I began to learn how my failure became my success.

I married very young and moved away from the reminders of my nightmare just to find out that it did not make me happy. So my secret internal journey began again where I wanted to redesign my life to escape the world of failure and strive for success. I used my beauty to enter contests, commercials, movies, and other star-struck opportunities for someone to notice my excellence and promote me out of this failure and into success. But after achieving these goals, I still found myself wanting to be more, to impress more, to gain more, to be there, and to get there.

But where was I trying to go?

What I found was that I was trying to get around life without actually living life. I wanted to live without living. I wanted something that I saw without realizing that what I had was designed for me to enjoy. Instead of enjoying life, I wished it away so that I could get to the next moment of wanting something else. Maybe I didn't know what happiness was, and I could not describe why. I did not have an internal description of happiness, so I asked myself, "What is happiness, and when do I know when I have finally found it?" It wasn't until God took me through a process that I found out that happiness is not what I possess; it is not who I am with, and happiness it is not anything that anyone can offer me. Happiness is the success I achieve when I accept my life with its imperfections and utilize what I have learned to change someone else's life. With a simple word I said to the Lord: *Yes*—I will accept my life as my journey to become the perfect me. Perfect does not mean I do not have flaws; perfect only requires me to be the best that I can possibly be. Then to *Him*, I am perfect for today and prepared for tomorrow.

As you learn about who you are, you will discover your strengths, weaknesses, some issues, hiccups, and hang-ups. Once those things become clear, you will understand why you were created. So let's dive in using the following thirty-eight chapters as a guide in the journey to discovering your true self and identity.

This book is designed to take you into the inner parts of your life and into the deepest hurts to help you get to the root of issues in your life and to help you identify who you really are and how everything in your life has purpose. Every pain will have its purpose for development in your future.

ASSESSMENT FOR WHY DON'T PEOPLE LIKE ME?

As we begin our self-assessment, please remember to be honest with yourself, or you will never develop the character necessary to become the real you. You don't have to share your answers with anyone else, but you must be prepared to be honest because you deserve the best you that you can be.

> *The more you get into God's Word,*
> *the more your results will look like His answers.*

We will now begin with real questions for a real assessment of your personal life. Again, in this section, you must be honest and truthful with yourself in order to get real answers and results.

Do not rush through the sections; remember, this is an assessment of your life to produce change and growth to become the "perfect me." The more time you take to answer these questions, the better your results will be. There are no right answers; there are only real results.

We have included a journaling section at the end of each chapter. Please write your answers and reflections on the pages provided.

1

Describe Your Parents and Who They Are

In this section, we will focus on the people who created you and deposited in you their strengths and their weaknesses. This section is necessary because we learn so much from our parents, but we don't realize how many of their strengths and their weaknesses we possess. This information will help formulate a description that will set you up for real reflections and true answers.

Please describe your parents. Start your descriptions with your father and then move to your mother. Before you start, I will share an example to help you describe them and understand how you see them as a person.

If you spoke with my children, they might say their father is ambitious, driven, and passionate and that he is a good role model. If they were to describe me, they may say I am a teacher, business owner, grandmother, friend, and mentor. These are fine, but they only define the descriptions of our performances as an individual.

If you were to ask them, *Who* is your mother? Their descriptions would likely change dramatically. They may say something like, "My mother is a perfectionist and desires nothing less than excellence from us. She pushes us to our purpose. She nitpicks until she can get us to move toward our purpose and doesn't let up until she succeeds. She loves us but allows us to make mistakes, just as long as the mistakes do not become our lifestyle. She questions everything that we do and believes her prophetic calling will show her everything we do, and we must admit to it or else."

That said, I am not sure how they would describe me because my assessment is not their reality. But I thought this example would give you an idea of what I am looking for in detail. This topic should be descriptive and intimate, only for your healing.

For some of us, our parents were instrumental in creating us, but they were not there to help us develop. For others, your parents may have been the very instrument in making you bitter. Be honest. Don't feel like you need to make them look pretty to me or anyone else. You must be comfortable in writing a clear description to help you identify yourself.

What this exercise will do is provide clarity as to why things may work the way that they do in your life. If you have never defined who your parents are to you, you

can probably see why you were never able to understand why you operate the way that you do.

Description goes well with clarity. They are virtually parallel.

After describing your parents, please reflect on the following questions:

- Were your parents a good example for you? If so, in what respect?
- Which one of your parents are you most like? Why do you think this is so?

1. Describe Your Parents and Who They Are.

2. **Describe your father. Write down 3–5 of his characteristics. What did he do well? How could he have improved?**

3. Describe your mother. Write down 3–5 of her characteristics. What did she do well? How could she have improved?

4. **Were your parents a good example for you? If so, explain in what respect? If not, explain how they weren't.**

5. **Which one of your parents are you most like? Why do you think this is so?**

2

Do You Know What Controls Your Heart?

The heart is deceitful above all things, and desperately wicked: who can know it? (Jeremiah 17:9, KJV, emphasis added)

The Word of God says the heart is "desperately wicked." Hidden there in the heart, we have wickedness and truth all in one place. Because the heart has the ability to be wicked, it can be easily deceived. So if the heart has the ability to lead me and to guide me, and it holds the wicked things of me, I have to know what's in it so that it does not deceive me.

If I desire certain things from God, when I receive things from people, I have to be able to discern what is good for me and what is bad for me. Remember, God gave us the Word, and it explains that not everything that is good for me is good to me, or good for my anointing.

But the anointing which ye have *received of him abideth in you, and ye need not that any man teach you: but as the same anointing teacheth you of all things, and is truth, and is no lie, and even as it hath taught you, ye shall abide in him.* (1 John 2:27, KJV)

My anointing feels very different when I walk in it compared to the satisfaction I receive when I walk in my flesh. Remember, what's good for me may not always be satisfying and what is good to me can make me happy, but being happy with something doesn't mean that it is good for my anointing.

For instance, food is good for me. It's nourishment for my body. But if I eat too much of the wrong thing, I may end up with high blood pressure, diabetes, high cholesterol, or other medical challenges. So, even though junk food was satisfying during consumption, in the long haul, was it good for me?

Another example are habits. Some people drink, while others may enjoy smoking. Though many Christians believe that these habits are sinful, I must say that I have not found that to be true in Scripture, so I don't teach against them. However, what I do teach is, anything that is a habit that takes precedence over the power and

the authority you have in God, then that act is sinful. So if my addiction requires me to have it, then it is sin because it has become the replacement for God.

There are some habits that develop stronger holds on us than others, which means it will take more of the anointing to break them off. One common example is the stronghold of pornography.

These strongholds become harder when we try to break free from their addictive behaviors. In the midst of the night, these strongholds awaken us with desires to be fulfilled. These desires will cause us to sneak and hide to become satisfied. Isn't that the same desire that one will have when it comes to smoking, drinking, or any other addictive behavior?

A friend of mine I once stayed with smoked for years, and no one ever knew it. But one day, while visiting, I walked into her bedroom to see her sitting on the window ledge of her private bathroom, her door was cracked open, smoking, blowing the smoke of her cigarettes out of her bathroom window. I asked, "What are you doing? I didn't know that you smoked." She said "No, no, no. You need to go out." I said, "How are you going to hide from yourself? That's crazy. This is your house, and you're hiding out, sitting on the ledge of an open window to satisfy your cravings and to fulfill your desires." Then I said to her, "I guess what your neighbors see isn't as important as what your friends know."

Isn't that amazing? But for her, she hid smoking from people because she didn't want her habit to be viewed as sinful. However, what you need to understand is the stronghold that you have is the sin itself; smoking is only the identifier of what you are being controlled by.

We are controlled by lots of things, some of which we don't even realize are controlling us. For instance, some people are controlled by their addiction to television; it's as if they cannot sleep without having it on all the time. Television is a consistent noise. But if you have noise in your ear all the time, can you really hear what God is saying?

Do you understand how controls operate?

They are any diversion that take your attention away from God. Anything that stops you and puts wind between what God can do for you and what satisfies you will identify itself as the sin that so easily distracts you. What habits or strongholds control you?

> *Grant not, O LORD, the desires of the wicked: further not his wicked device; lest they exalt themselves. Selah.* (Psalm 140:8, KJV)

In the things that you desire, you have to determine: Are they real desires, or are they filling some sort of loneliness?

Desires can be very deceitful. They can control you and even manipulate you. We desire some things that really are not godly.

Some people may say, "My lone desire in my life is to own a Bentley, Rolls Royce, or a Maserati." Why would you want to own a vehicle more valuable than the average middle-class home? I think it's crazy to see people driving up in luxury vehicles to an apartment complex. That's ludicrous to have a car note that is more than your mortgage. You should adjust your philosophy to own where you sleep, before you own what you drive!

I remember a conversation that my dad had with me when my husband was in his thirties. I said, "Dad, Randy wants a Jaguar car, and I would like to get him one for his retirement." My dad said, "You don't rate a Jag." I said, "What? I beg your pardon? I have a few college degrees, and we have worked really hard to get where we are. We have really good jobs. What do you mean?" He said, "You don't put child car seats in these types of vehicles. If you need to put a car seat in a Jag, you need to wait because they were not meant for that."

These vehicles say, "I have arrived." When you can invest more money in your car than in your children's education, your priorities are not in order. You shouldn't be worried about what you are going to be putting in your car; you should be worried about what you are going to be putting in your children. My dad said, "You don't rate that yet. Older, settled people get to drive Jaguars. Young people just don't need those pressures in life."

Well, we didn't get a Jag, but that made so much sense to me. When I see young people driving expensive cars with a car seat buckled in the back, I say to myself, "What are they about to sacrifice to keep up with that image?"

Are your desires godly, or are they filling an empty space?

> *Hell and destruction are never full; so the eyes of man are never satisfied.* (Proverbs 27:20, KJV)

> *Desires are temporary satisfactions.*
> *They are* never *permanent solutions.*

Depending on where you are in life, you may be either in a storm, coming out of a storm, or about to go into a storm. Life is never stagnant, so you will always have something going on in your life. Storms were designed to prepare you for what's ahead, but you must determine how you will adjust.

Be mindful that everyone is going through something, so you cannot expect for their focus to always be on you. Also, we all have our own demands and needs that we want satisfied. Thus, building a true relationship is about give and take. Be able and available to give when needed. If you do this, the other person will likely return the same, and you all can begin to build a solid, lasting relationship.

Both people will determine how a relationship will evolve and choose to make the necessary changes to develop a connection or refuse and walk away. However,

only you can determine how you will adjust because no one can become everything you desire, and neither can you become everything they desire.

How much of you are you willing to change to satisfy others?

List the parts of you that you are not willing to change.

> *And you hath he quickened, who were dead in trespasses and sins; Wherein in time past ye walked according to the course of this world, according to the prince of the power of the air, the spirit that now worketh in the children of disobedience: Among whom also we all had our conversation in times past in the* **lusts of our flesh, fulfilling the desires of the flesh and of the mind**; *and were by nature the children of wrath, even as others.* (Ephesians 2:1–3, KJV)

Two things that are in the heart are wickedness and truth, both living within the same body. To be honest with yourself, you must be willing to know the strength and the weakness that lie deep within your heart.

My example of truth is this: I'm very independent, and I like to do things for myself, but my heart's desire from people is real truth. I don't like people who say one thing but live another way.

I also don't like people who say "I love you," but their heart is so far away from me.

What I need in my life are people who want to live for God from their heart and not with words only.

Wickedness is the quality of being evil or morally wrong.

My example of wickedness is this:
We often overlook what we don't have to address until it changes who we are from what we should have become.

My struggle hidden deep within my heart was unforgiveness.

So, how did unforgiveness affect me? It limited my ability to receive, to learn, or to receive love from those I chose not to forgive. Unforgiveness was a control that guided my path, but I had a real come-to-Jesus moment, and I had to ask myself, "Why did you give something so small so much power over your life?" This was possible because I did not learn the power of forgiveness. Unforgiveness gained the power to develop within me wickedness. From this I learned that wickedness is what you struggle with when no one else can even recognize that it exists. I also learned not to allow what I can control to control me.

These are the desires that I have because I want to live my life in a way that when I leave this Earth, I will leave a legacy of change and spiritual prosperity.

I would love to see my legacy endure so that my children and grandchildren will know that I was a true woman of God. I want to have a legacy that outlasts my life on Earth, but I want it to be one that has a spiritual connotation. This is my heart's desire.

List at least two things in your heart that control you.

The closer you get to God,
the more answers to life you will get right.

1. Do You Know What Controls Your Heart?

2. What habits or strongholds control your life?

3. Why do these habits or strongholds control your life?

4. **What desires do you have? Are they Godly or fulfilling an empty space?**

5. **List the parts of you that you are willing to change to satisfy others.**

6. List the parts of you that you are not willing to change to satisfy others.

7. List your strengths and weaknesses.

3

Why Do You Push People Away?

> *Thou art my King, O God: command deliverances for Jacob.*
> Through thee will we push down our enemies: through thy name
> will we tread them under that rise up against us. *For I will not
> trust in my bow, neither shall my sword save me. But* **thou hast
> saved us** *from our enemies, and hast put them to shame that hated
> us.* (Psalm 44:4–7, KJV)

Here, the Bible talks about how the enemies of God are my enemies, how they should not be my friend but rather my foe. We often walk through life thinking everybody who comes in contact with us should be our best friend. I don't agree. Every time someone comes into your life, there is an assignment, and the assignment says what you are required to do in their lives or what they are required to do in your life. I believe there is a place for everyone and not everyone has the same place. Some people have positions in your life while other people have places in your life.

Here are some points to evaluate yourself as you assess you.

> *So then faith cometh by hearing, and hearing by the word of God.*
> (Romans 10:17, KJV)

When you learn without listening, then you learn to trust only what you can see. This will cause you to respond to what you see instead of receiving what you should be learning. If you cannot hear the voice of God, you will never be able to identify or position people where they belong in your life. Listening to God means being able to understand why people are in your life.

When people come into my life, I always ask God, "Who are they to me? What is their place in my life? What is my place in their life?" Then, I immediately categorize people into their position in my life, or I categorize them out of my life right away. I do this because I don't want to make a mistake with their lives, and I definitely don't want them to make a mistake with mine. It's really important that this evaluation of people happen, because people often take God's anointed lightly.

To people who handle me carelessly, I say, "Do you even know who you have in your presence? Do you care?" I know that people often misuse those called by God, but do they recognize that they were sent by the Lord? Do they even understand what they are doing? Do you handle the people of God like that? How do you handle God's people? Just ask yourself, "Were they sent to me on an assignment and am I now becoming their wrath?" Their purpose could be to help you out of your struggles, to be your strength through this season, but because we can't hear God and we don't know the purpose they serve in our lives, we mistreat them and abuse them.

> *Beloved, believe not every spirit, but try the spirits whether they are of God: because many false prophets are gone out into the world.* (1 John 4:1, KJV)

We have seasons in our lives when we don't know what we are going through. We often push people away from us when we don't understand why they are there to assist. We say to ourselves, "I don't know what I'm going through! I don't know where I am! I don't know if I want to be with God or go back to the world. I don't know if I want to get married or if I want to be single." Have you ever wanted to just quit? Have you wanted to do so every week of your life? If we go through these cycles every week, we must admit to ourselves that we really do not know where we are in Christ. I had a moment one time when someone asked me, "Are you ready to quit yet?" I said, "No! I'm just frustrated, but I don't want to quit." I came to realize that every struggle is not a bad seed. Struggles were designed to strengthen those things that are weak. When I'm focused, I know the enemy is going to come against me to distract me and disturb what I am accomplishing. But when I walk fully with God, I don't hang out with the enemy. We don't talk or chit-chat. When I come into to the room, I must command him to get out! I understand that some things are going to come against me. But we have to ask ourselves, "Why do we do what we are called to do, and at what cost are we going to complete it?"

When people come into our lives to push us to our destiny, we often push back with resistance due to our inability to move toward destiny. Could it be because we don't like change? We have some people who know they are called to be great, but there are many others who question their calling and their purpose. Ministry is a person or thing through which something is accomplished. For Christians, it is the works of God that are accomplished by man under the directions of the Spirit of God.

Do you know if you have been called into ministry?

Do you have a drive within you to change people's lives?

There are moments when you really will want to push back, and you will. When we see ourselves moving toward the big things that God has called us to, it sometimes gets frightening—so much so that we push back saying, "I'm not ready for that." We

say to ourselves, "I don't know why God called me. I can't deal with that. I'm not willing to rid my life of that yet. I don't want it." We often push back because of our inability to move toward destiny, which is what He has called us to. He is going to equip you. Yes, life like that is scary. It is scary! It is really scary to be called into a life where you have others depending on you. That's huge. The thought of walking into a calling while knowing what you are going to carry is overwhelming; nevertheless, He called you to do it. More than that, He is expecting you to do it. Don't push back. Stop saying, "I'm not ready yet" or "I can't do this right now." Go for it!

Destiny has been designed for you.

> *But God hath chosen the foolish things of the world to confound the wise; and God hath chosen the weak things of the world to confound the things which are mighty.* (1 Corinthians 1:27, KJV)

> *And he said unto them, "Unto you it is given to know the mystery of the kingdom of God: but unto them that are without, all these things are done in parables."* (Mark 4:11, KJV)

God often takes the foolish things to confound the wise so it may look crazy. But it's by design. Why does God take people from the street, save them, and then in a year, place them on the pulpit to preach? Because, for some people, change is such an epiphany that when change happens, he or she immediately understands the mystery of his or her destiny.

The problem with people who have been in church for years who have not been working with people who are not in church is that we forget what it was like when we were the un-churched. We forget what the fight was like. We forget how to appreciate the struggle to survive, so we push against what we've forgotten.

I often hear people say, "Well, I am who I am going to be. This is just who I am." That's scary. That means you are stuck without a desire to be different. When your children are small, you are known as their mom. When the kids leave, you are going to grow, and your identity will change. Your life is going to change, and it will keep changing. You will keep evolving as you get older, and life will reclassify you.

Take a few minutes to look at the important people in your life over the last ten years that have either walked away or disappeared from your life. Ask yourself, "Did I push them out of my life?"

Question:

What if some people just leave my life without an explanation?

Answer:

Some people have a reason to leave. This is not about them; this is about you. We aren't talking about their decisions; we are talking about our decision. We can't change what people do. We can only change how we respond to what they have done.

God requires us to allow people into our lives because people are a necessary balance for us. However, we judge people while refusing to allow God to properly judge us. We want to look into the lives of people to critique and criticize them, but we ourselves do not like to be evaluated. Some things that we do to others, we cause God to allow the same measures to be done to us. These are hard realities of relationships; we wonder why people walk away, and we don't understand that we pushed them away.

1. Why Do You Push People Away?

2. List the reasons why you would push people away.

3. **How do you handle people of faith? How do you handle people with different faiths than you?**

4. Describe a time you wanted to quit.

5. How often do you want to quit things you've started?

6. **What is it that you have been created to do? At what cost are you willing to complete it?**

7. What have you been called to do in ministry?

8. Explain the desire you have within you to change people's lives.

9. Think of a time when someone of great importance left your life abruptly without explanation. Did you push them away or did they walk away on their own? Explain the reasoning behind your response.

4

Do You Seek Affirmation or Confirmation?

This is a faithful saying, and these things I will that thou **affirm constantly,** *that they which have believed in God might be careful to maintain good works. These things are good and profitable unto men.* (Titus 3:8, KJV)

You should seek to affirm others to good works and not be confirmed by those around you. The Word of God says the whole purpose of us showing confidence in God is to encourage our brothers and sisters. We should be the ones that say things like, "Good job," "Great work," or "What can I do to keep you encouraged?" If you are spending your life waiting for someone to pat you on the back, you are in the wrong place, and your behavior is not a model of Scripture.

The Word of God says that we should be careful to maintain men unto good works. The whole purpose of ministry is to remind you that it's not about you. Ministry is a message to the world that we are doers and God's people. The goal of ministry is to complete a work on earth that God has placed within us. It's a spoken word, and it is a living word. The Word of God speaks through us, and we operate through His instructions.

The anointing is great, but it doesn't work without obedient men and women. We like to think that the anointing has the ability to do everything by itself, but the anointing operates through people. When God speaks, He speaks through man. If God can use a donkey or a burning bush, then He absolutely can use you. But in order for that to happen, you have to be able to hear Him. The only way you can hear is when someone speaks. So, that means the anointing operates through people.

Ye are our epistle written in our hearts, known and read of all men: *Forasmuch as ye are manifestly declared to be the epistle of Christ ministered by us, written not with ink, but with the Spirit of the living God; not in tables of stone, but in fleshy tables of the heart.* (2 Corinthians 3:2–3, KJV)

The anointing operates and moves through the power of the Word of God that dwells within us. That's why the Word of God says you are a living epistle. It means you are a living word, a living testimony, and a living operation of what God is doing through people.

It's not us, because we can't do all the things that we do within our own strength. After all, it would be crazy for me to trust in my own strength. Who else can operate under this type of strain and not break? Only God. I know that it's only God in me that gives me the ability to do what I do. If you left me to myself, I would go get in bed, pull the blankets over my head, and sleep for two weeks.

My flesh is tired, but when I'm operating under the instruction of the power of God, I can do lots of things without breaking. We have to remember, the Word of God says our responsibility is to push His people to good works.

> *And let us consider one another to provoke unto love and to good works.* (Hebrews 10:24, KJV)

God told me once, "When I anoint you, many times you can't even identify that you have the ability to be great until someone applauds your performance." An applause is our first identifier that we hold something someone else was not able to do. This type of affirmation shows our greatness.

Let's take my daughter for example. We never knew she could sing. We went to a community talent show with hundreds of people, and she said "Mom, I'm going to enter the talent show." I was numb. I thought to myself, "They are going to hurt my baby's feelings, and she's going to cry all the way home."

So to distract her, I said, "Would you like to go get some ice cream?" and she said, "No, I just want to wait for my turn." I was thinking, "Oh, this is not going to be good. If she gets up there and starts singing and bombs, I don't know what I am going to do."

When they called her name, up she went for her performance. The moment she began singing, her dad and I looked at each other in total amazement. The voice that came out of her was like nothing we had ever heard before!

We both asked each other, "Did you know she could sing?" We never knew our daughter could sing until she got up to perform. Afterward, the audience applauded her and gave her first place. All I could think was, *What just happened?*

Later I asked her, "How long have you been singing?" She said, "I sing all the time in the shower."

Within a moment, she received one applause and then promotion. Almost immediately after the talent show, she started writing songs and singing, and she has never stopped. She now writes a song a week and has really developed in her gifts.

Isn't it amazing how some gifts are just hidden, waiting for an opportunity to show themselves? Sometimes all it takes is just one applause. God showed me that an applause is a recognition of the greatness that is hiding within us.

Affirmation is used to build the confidence of those doing a good work so that they may continue to press forward. It is not meant for those who are seeking attention.

One thing about affirmation, if you get too much of it, it's not good. But if you don't get enough of it, it's not good either. You need the right balance. If you give too much affirmation to people, they may begin to believe it is them doing the work and not God. If you don't give people enough affirmation, they may burn out because they won't know that God is doing a work through them.

When people are doing an operation of ministry, whether it be in a church, a home, a school, or somewhere else, reaffirming them and encouraging them to keep going is a healthy thing.

But we also must ask ourselves, "Why are we doing our works? Are we doing them to be applauded or are we doing them to be affirmed?"

There are certain things that I like to be affirmed of when it comes to ministry. For example, when I must embark upon unfamiliar territories, I look for confirmation from God to know that I am doing what He said.

I don't have to be recognized for what I do in ministry because, personally, I understand this is who I am. However, when it comes to my family, I'm a little different. If I cook dinner for them, I expect them to say thank you. My children in the after-school program are taught that when they walk in a room, they should speak to everyone else in the room to allow them to recognize their presence.

So when we are working in ministry, understand that what God has confirmed for you to do may never get affirmation from others. It is your assignment. It is your call. It is your purpose.

People should affirm you, but it is not something you should seek. When you look for affirmation that means you are seeking the applause. When you are seeking applause, you have the wrong motive and purpose. You should not be seeking anything but confirmation.

1. Do You Seek Affirmation or Confirmation?

2. Why are you doing your works?

3. **Are you doing them to be applauded or are you doing them to be affirmed? Explain.**

5

Do You Need People in Your Life?

And the apostles, when they were returned, told him all that they had done. And he took them, and went aside privately into a desert place belonging to the city called Bethsaida. And the people, when they knew it, followed him: and he received them, and spake unto them of the kingdom of God, and **healed them that had need** *of healing.* (Luke 9:10–11, KJV)

The Word of God states the apostles were at a place where they were seeking the Lord privately with Christ, but the whole purpose was for healing to be released. We often design our lives so that we don't need people in it, but the Word of God teaches us there is a need for people in our daily walk.

God will not allow you to go through certain trials in your life until certain people arrive to go through them with you.

Let your conversation be without covetousness; and be content with such things as ye have: for he hath said, I will never leave thee, nor forsake thee. (Hebrews 13:5, KJV)

God said in His word that He will never leave you nor forsake you. *Forsake* means "to abandon." If He said He will never leave or abandon you, that means He is always going to allow you to have people in your life to comfort you.

Ready for a spiritual check?

Beloved, believe not every spirit, but **try the spirits** *whether they are of God: because many false prophets are gone out into the world.* (1 John 4:1, KJV)

Have you ever been through something in life that you went through alone? Did you come out by yourself?

The Word of God says, "Try the spirits whether they are of God." God's Word always confirms itself. His Word declared that He would never leave us. Please answer this question: Has God ever left you alone?

Regardless of how hard and troubled life gets, God will always send someone in your life even if He has to redirect their paths to do so.

Do we always receive people?

Have you ever put someone out of your life and thought about it later and said, "God, I need [insert name here], but I can't call them because of how I treated them?" God always brings people into your life. He will never allow you to go through anything in your life and not send you a comforter.

People carry His anointing as a comforter for our tribulations. So the anointing is carried and supplied to us to complete a specific task.

However, the anointing is not omnipresent. I wish I could teach that it is, but it isn't. It is not always available, and it does not always carry power for you. For instance, even though the anointing had departed from Saul, the Word of God told David, "Touch not my anointed." But when Saul went to the seer for instruction, Saul could not hear from God himself. So here we see Saul was a man of God that was anointed but did not carry the power of God. In other words, the anointing does not always have power. That doesn't mean it's not always powerful; you just may not be at a place with God in order for the anointing to be used.

1. Do You Need People in Your Life?

2. Explain how you need people in your life.

3. **What have you endured in life where you felt like you were alone? Upon reflection, was there anyone who was there for you during those times?**

4. Describe a time when you felt like God left you alone.

5. Is it difficult for you to receive help from people? Why or why not?

6. Have you ever put someone out of your life and thought about it later and said, "God, I need [insert name here], but I can't call them because of how I treated them"? If you were able to reconnect with them, explain how. If not, what prevented you from doing so?

6

What Reconnects You to Hurt in Your Life?

Is it new hurt? Is it the thought of hurt? Is it the sarcasm that came with the hurt? Is it the memories about a previous hurt? Is it the new people that came in your life that resembled past hurt?

> *And David danced before the LORD with all his might; and David was girded with a linen ephod. So David and all the house of Israel brought up the ark of the LORD with shouting, and with the sound of the trumpet. And as the ark of the LORD came into the city of David, Michal Saul's daughter looked through a window, and saw King David leaping and dancing before the LORD;* and **she despised him in her heart**. (2 Samuel 6:14–16, KJV)

I often think, Why did Michal despise David in his worship? What was in the worship that reconnected her to a suppressed anger? Then I thought about it; Michal knew David as the psalmist for her father. David played instruments, sang melodies, and entertained Saul. David was the person who brought and ushered in the presence of the Lord for her father. But now looking out at David as the king, she remembered her family. Her father is now deceased, and when she looks at David, it may be that all she sees in him is the man who replaced her father. His worship may remind her that David is the reason her family is no longer with her. She may resent him for that. A moment that should have been a time of rejoicing became a place of suppressed anger and resentment.

What reconnects you to hurt? What triggers your resentment? We all have a trigger that takes us back to a certain place in our lives. We all have something that makes us remember those moments that make us angry or drive us mad.

What is madness?

Madness is a place you have to go to. It's a location that is outside of everything we refer to as life. Every time madness arrives, you have to leave where you live and go to where it resides. Madness has an address, and in order for you to visit, you must go back to where it lives, where it exists. The reason you have to leave to reconnect

to madness is because life has taken you through it to make it become a part of your past. However, when we remember madness, we have to go all the way back in our past to where it lives.

Madness is a place; happy is a choice.

Let's talk about one of those moments in life that made you very angry.

Can you describe a moment in your life that truly made you mad? Can you remember it as clearly as if it were yesterday? Where did you go mentally to remember those moments?

When you get there, it becomes so clear that you could almost remember what you were wearing, the location, who was in the room, what the aroma smelled like, and every word and action made. You see, madness is a place, and it has a location in your life where things are compartmentalized. Because these moments are not a part of today, you can live happily without them. Or you can choose to remember and have them become a consistent reminder of what was and may not be very relevant today. We all have these moments in our lives, but are they good? They are only good if you use them for growth and purpose to elevate someone's life. But if it is to hold resentment, the answer is no. It's never good to stay mad. It isn't good for you or the person you are angry with.

> *HURT Feelings never die;*
> *they just lie dormant and are revived by the smallest feelings.*

My testimony:

By the end of my first year of marriage, I wanted a divorce. But God said no; it wasn't His desire.

I was convinced that I wanted out, so mentally, I checked out. But I was too afraid of God to leave. My friend would ask me why I didn't like my husband, but all I could say is, "I just don't like him." It was crazy, but I had put it in my head that I didn't like him, and that is where I stayed. I was angry with him, and I could not let madness go.

When I wanted a divorce, he wouldn't sign the divorce papers. So, I made multiple copies of the divorce papers, and I plastered them all over the house while telling him, "Whatever day you decide to sign one of the papers, I'm ready." I only needed one original signature, but thankfully, he never signed one of the papers. And that's why we are here today, because God gave us a testimony of how He can heal the heart and deliver you from past hurts.

During that time, one of the things God said to me was that I had trained myself not to like my husband, and now I had to train myself how to love him. God said to me, "Every time you feel like you don't like him, you need to say 'I do love my husband, I do love my husband.'" I would have to speak that into my spirit every day for months. Every time I would visit the place called madness within my mind,

I would tell myself, "I have to get out of here." I did this by reciting "I do love my husband, I do," until I was able to walk myself out of that place and back to my current life. I could not allow the enemy to take my mind or my heart captive because I loved my husband. I loved him, and I would have to speak it until my flesh lost its control over my mind.

I remember one day that I was so mad at him that I went in the bathroom, looked in the mirror, and said to myself, "You love your husband, you do. You do love him." My husband came in the restroom where I was and asked, "Who are you talking to?" I just looked at him and said, "If you only knew."

I was too afraid of God to walk out on His instructions because I understood His plans are better than my thoughts. When going through this ordeal, I didn't have any clue we would birth a ministry because of it. I had to realize that I couldn't let that place hold me captive any longer. I had to break out whichever way I could, and for me, God said I had to speak my deliverance into the atmosphere. He said, "You control your flesh, your flesh doesn't control you. Your flesh will come under subjection only by what you command."

For me, it was my marriage that held me captive. I had to fight every instance in me that would tell me to quit.

Are you still angry?

If you can talk about something today that really hurt you in the past and it makes you as angry today as it did when it first happened, it's time for you to deal with it because you are not safe place. What I mean is that place you visit can cause other things in your life to appear to be reenactments of your past, and you become a victim today from your hurt yesterday.

This is one of the reasons so many of us have multiple marriages and are in multiple relationships, all because we don't know how to deal with what we went through. We have to let some things go and accept what God has allowed us to go through as growth.

For many of us, those moments or places can be very explosive, so they're not safe for us, and we are not safe to be around other people when we are there. We have to be careful enough to identify where those places are. We have to be careful of what takes us back to them. We have to be able to identify what makes us angry. We have to know who, what, where, when, and how we get back to the place called anger.

After we are aware of those things, then what we have to do is consciously fight against it. We have to talk ourselves through the memories and back into reality.

1. What Reconnects You to Hurt in Your Life?

2. **Is it new hurt? Is it the thought of hurt? Is it the sarcasm that came with the hurt? Is it the memories about a previous hurt? Is it the new people that came in your life that resembled past hurt?**

3. What triggers your resentment towards people?

4. **Describe a moment in your life that truly made you angry. Why did you act that way? Why was this anger more intense than other moments in your life?**

5. **Share a past hurt that remains a current struggle. Explain where you went mentally and emotionally in that moment.**

6. **Are you still angry about a past hurt? What will it take for you to heal from that past hurt?**

7

Do You Have a Mentor in Your Life?

What is a mentor?

A mentor is someone who has the ability to pour into your life from their experience. A mentor is not perfect; and many times they have flaws. However, they have the ability to translate their failures into knowledge to prevent mistakes from reoccurring in others' lives. A mentor should be able to take your tragedy and direct you to the purpose of its hidden pain. They hold the ability to take the pains of life and make them tolerable enough to face while bringing out the greater things hidden within you. A mentor can be a friend, but their purpose for your life is to get you through your experience, without you having to go through it yourself.

> *Therefore Eli said unto Samuel, Go, lie down: and it shall be, if he call thee, that thou shalt say, Speak, LORD; for thy servant heareth. So Samuel went and lay down in his place. And the LORD came, and stood, and called as at other times, Samuel, Samuel. Then Samuel answered, Speak; for thy servant heareth. And the LORD said to Samuel, Behold, I will do a thing in Israel, at which both the ears of every one that heareth it shall tingle. In that day I will perform against Eli all things which I have spoken concerning his house: when I begin,* **I will also make an end. For I have told him that I will judge his house** *for ever for the iniquity which he knoweth; because his sons made themselves vile, and he restrained them not.* (1 Samuel 3:9–13, KJV)

Eli was a mentor to Samuel. Eli understood that the time had come where he must deposit his wisdom into the person who was to replace him. A mentor understands that wisdom should be shared so that others would not perish. A mentor must be confident enough to take their shame and use it to produce greater results.

Here we have Samuel and the sons of Eli, who were examples of how a godly environment does not always produce a great product. When Samuel's mother,

73

Hannah, desired to have a child, she went before the Lord and trusted He would do what He promised her. In turn, she promised God that she would give her son back to the Lord by returning him to the priest by whom her promise was spoken.

Samuel did not have a mother or father around who trained him on his daily walk. The Word of God declares Hannah visited Samuel yearly. The role and responsibility of training Samuel was given to Eli. Samuel was trained by the priest to learn how to become a priest. The Word of God also says Eli, the priest whom God chose to raise Samuel, had sons that were priests that should have taken Eli's place at his departure. However, God said they were polluted with something that disqualified them from their appointment. So the same man who raised disobedient sons raised Samuel, who became righteous in the same environment. Samuel came out with purpose while Eli's sons were passed over.

Having a mentor is very beneficial. The increase in the quality of life you gain can increase your self-worth exponentially by giving you what you never knew existed within yourself—greatness. Understand that greatness is not born, and greatness is not accidental, but greatness comes from making great sacrifices that can sometimes be painful. It also comes from dedication and determination. Are you willing to commit to becoming great with the same commitment that Hannah made for Samuel? If you are determined to commit to yourself to become great, then find someone qualified and determined enough to bring out your greatness. But understand this: you must be willing to be offended, confronted, and questioned, and you cannot walk away. Regardless of your disappointments, you must commit to change and allow pain to develop your greatness.

> *And Samuel said unto all Israel, Behold,* **I have hearkened unto your voice in all that ye said** *unto me, and have made a king over you. And now, behold, the king walketh before you: and I am old and grayheaded; and, behold, my sons are with you: and I have walked before you from my childhood unto this day. Behold, here I am: witness against me before the LORD, and before his anointed: whose ox have I taken? or whose ass have I taken? or whom have I defrauded? whom have I oppressed? or of whose hand have I received any bribe to blind mine eyes therewith? and I will restore it you. And they said, Thou hast not defrauded us, nor oppressed us, neither hast thou taken ought of any man's hand.* (1 Samuel 12:1–4, KJV)

The Word of God states that Samuel saw what the sons of Eli did, but made a choice not to repeat their errors. There comes a time when you must make the decision to say, "I have experienced some negative things along the way, but I am going to make a choice to do what pleases the Lord."

So when looking at your relationships, to say you behave a certain way because of where you came from is unacceptable. When you learn something new, you must adapt. We all come from somewhere. We all have been through something.

Was there anything great that you gained from a past tragedy? Should the things we experienced when we were young still offend us today? Everything should have an expiration date.

My life has had some real challenges. I was kidnapped from the neighborhood where I grew up and played as a child. I was only ten years old when I was sexually assaulted. Because of this I became timid and I lost my confidence. So having a mentor for me helped to motivate and encourage me to venture out of my comfort zone. There were great things in me that were being held captive because of my fears.

We all came from somewhere and went through something, but when are *you* going to make a decision to say, "I am not going to allow what happened to me to declare what I shall be?"

1. Do You Have a Mentor in Your Life Today?

2. Who has been your mentor in life?

3. Describe what is a mentor to you.

4. **What are you willing to commit to doing in order to become great?**

5. What did you gain from a past tragedy?

6. **Describe an experience when you were young that still offends you today.**

8

What Is the Average Length of a Friendship in Your Life?

After this teaching, my hope is that instead of loving everyone who comes into your life with a tolerance, you will love them with an understanding that you can like something in everyone, even if it is only their smile.

Do you commit to lasting relationships?

Remember, commitment does not mean you must have daily communications, but it requires you to have a continual relationship.

What is the average length of a relationship you will commit to?

Do you have the ability to nurture through pain, disappointment, and personal hurt?

This part of having lasting relationships is very difficult because when people get on our nerves, we tend to destroy relationships. We destroy them because the flesh is selfish, and it thinks about satisfaction versus fighting for what is important.

Friends are very important! When people tell me they don't have any friends, it means they can't be trusted. I believe those people are saying they have some issues in their lives they cannot get right, so they don't want anyone close enough to identify their weaknesses because they are not ready to get right.

Worse yet, some people are so busy doing their own thing that when others get too close to them, they push them away in fear of commitment, in order to shield themselves.

When you have the ability to nurture through pain, what you do is nurture through things that hurt. Remember, not everyone who comes into your life will come whole. We often believe that people who come to church are saved when they come through the door. That is a mistake. If people come to church with the ability to see all and do everything right, why would they need God?

People also come to church and think pastors are perfect. They believe pastors should never make a mistake, and if they do, judgment and condemnation quickly follow. So when people need their pastors, they can't call them because the enemy uses judgment and condemnation to drive a wedge between them, the church, and

their pastors. When these thoughts get hold of you, instead of you being able to reach for the phone to receive wisdom, you hesitate. So you can't reach for the things you need because the enemy has convinced you that your access is denied.

This is how the enemy teaches us to respond in relationships—he doesn't want you to have people in your life to keep you encouraged and balanced. He wants you to be alone so that he can talk to you all by himself.

In some cases, people have been your friends and have done really well by you, but when they did something you did not like, you began to build walls. So you have bridges that you cannot cross to people whom you need, all because of you. Self is a big thing. People are not your enemy; fear is your enemy.

Do you love to death without the ability to restore to life?

People often say, "I love you to death." I don't think death is a good place, so I prefer to say, "I love you to life."

Death is the end of a thing, right? So when you love someone to death, are you saying that you will love them only to the end of this relationship? When you love to life, you are saying you are going to love someone with the ability to restore them out of whatever they go through and back to life again. "I love you to life" means when you do things to me that hurt, I make a commitment that I will be willing to love you through it.

Sometimes people may come to you and share everything with you, and you say to yourself, "I do not know why they are telling me all their business. I really don't care." This means you are being a friend to people, but people are not a friend to you. It's just a one-way relationship.

One of the hardest things in life is to be a friend to someone and find out they were not a friend to you. You shared everything with them, but they took you as a joke. That can make you hate them.

Was that you? If so, would you like *you*? This is how we behave, and then we ask ourselves, "Why don't people like me?" Do you see yourself in this?

> Now, pray this prayer:
> Lord, please do not let my desires get in my way.
> Lord, don't let my desires get in Your way.
> Lord, make my desires line up with Your will for my life.
> Lord, line up my will with Your will for my life.
> Lord, I want my desires to line up with Your will over my life.
> Lord, I want You to lead me in the path of righteousness for Your name's sake so that I won't be deceived by the snares of the enemy.

Here are some examples of Biblical desires that you may consider for your mate:

- Lord, I want a mate who I can trust and one with the ability to handle finances responsibly. I want my mate to have the spiritual gifts of Ahijah who was over the treasures and the dedicated things in the house of God, as found in 1 Chronicles 26:20.
- Lord, I want my mate to have a strong business mind with skills to help me develop my business. I want my mate to have the gifts of Chenaniah who you allowed to handle the outward business over Israel for officers and judges, as found in 1 Chronicles 26:29–30.
- Lord, I want my mate to be strong, confident, and courageous like Meshelemiah who had sons and brethren, who were all strong men, as found in 1 Chronicles 26:9.

However, after all these desires, you should refer back to God for Him to approve your desires.

1. What Is the Average Length of a Friendship in Your Life?

2. What is the average length of a relationship you will commit to?

3. How do you commit to developing lasting relationships?

4. **How do you nurture a relationship through pain, disappoint-
ment, and personal hurt?**

5. **If people come to church with the ability to see all and do every-
 thing right, why would they need God?**

6. **Explain how you could love someone to death without also restoring them to life.**

9

How Do You Describe a Friend?

Are you looking for certain qualities? Do you want certain things? In order for you to receive these things, you have to be able to describe what it is you desire.

Many of us are looking for things in a relationship, but we have never been able to identify what they are. One may say, "I just want someone I can depend on." But is that what you really want? Before you can receive someone you can depend on, you must first know who you are and decide if you are willing to be dependable. Many times we want something, but we really don't know who we are, so we must ask ourselves these questions:

- What am I really looking for in a friend?
- How does it fit me?
- How do they qualify to become a part of my life?
- Where do I place the importance of people in my relationships?
- How would I describe a friend?

My friends are people with whom I am able to be myself. I have friends who serve distinct roles in my life. They help to keep me motivated, balanced, and sharp. Everything does not have to be scripture-based as long as it is spiritually balanced. They have the ability to pull out different purposes from within me. They help me become who I am. They help me to become the perfect me.

For instance, I have a friend whom I just like to shop with. I can call her at any moment of any day and go anywhere, and she is ready. We have a lot of fun shopping, but when I need to pray, I'll call someone else.

There is a young girl in my life whom I can just be silly with. She makes the laughter flow out of me. When I am going through rough times and I need to get out of my funk, I call her. I need that because everyone needs to laugh, and that's a part of who I am.

I have another friend who is more of my spiritual leader. She is a person whom I look up to. When I have life-changing goals that I am striving for, I will always call her. She lets me know how to keep things in order. She is strong, confident, and

experienced. She knows how to talk to me in a manner that helps me keep myself together as a professional. She makes sure I know how to operate in the presence of millionaires.

If I am walking in my anointing properly, then my anointing should recognize His anointed. So when God brings people into my life, I should not have to question their presence because my anointing should recognize who they are and why I need them. Therefore, I must identify what I need before I can recognize it in someone else.

For example, when someone is assigned to my life for a specific purpose and for a designated season, I should not have to pray about who they are to me. Because I have been seeking the Lord for instructions to help become a better me, a confirmation from the Lord should arise in my spirit when they arrive. By the Spirit and their speech, I should know that the I Am sent them. I know they won't fulfill every desire for my life; they can only complete the assignment they have been given which they are qualified to accomplish.

No one person in my life helps to make me complete. I have an array of people in my life who look very different from one another. What this does for me is allow me to have a balance and an array of the anointing. It helps me stay balanced in life and spiritually sound.

I have to know what I am looking for and realize I will not find one person who is qualified to satisfy all my needs and equip me for every assignment at any given time. When we put all our investments into one person, chances are we are not going to fulfill something or we are going to be disappointed because they were not able to give us everything we needed. So we push them away because they could not fulfill all our desires.

Who is this person in your life? What position do they hold, and why are you trying to make them a god that they should fulfill everything in your life? That's not their purpose; that isn't even fair. One person does not equal fulfillment in one's life. Allow people to add to your life, not dominate. God gave us an array of people to choose from. They all serve different purposes. Open your heart and try something new.

Looking for a mate

> *Delight thyself also in the LORD; and he shall give thee the desires of thine heart. Commit thy way unto the LORD; trust also in him; and he shall bring it to pass.* (Psalm 37:4–5, KJV)

He gives us exactly what we give Him. When seeking a mate, you must be able to clearly identify your desires; in order to do so, you must identify what you are willing and capable of giving. We come from different backgrounds and there-

fore we develop different tolerances. For this portion, you must be able to clearly describe what you are willing to put into a relationship to make building a relationship possible.

For those women who are seeking to find a mate, we have designed this section specifically for you.

Things you need to know when seeking a mate

Before identifying a mate, please list at least twenty characteristics you desire your mate to have. These traits will become a requirement for anyone you consider becoming your mate. Before you consider dating a person or place all your feelings into the relationship and drop all your bags at their front door, you must be able to identify what you desire in a mate and not be moved by what satisfies your flesh.

This is a physical list of traits that you must keep available for comparison. The reason you need to list your desires is so you don't constantly change them according to how you feel. Feelings can change daily. You don't want your list to change, or you will never find what you are looking for.

After you list the twenty things you desire in a mate, you must then narrow down your list to a top 10. The top 10 desires must be determined by what you must have in a mate over anything else.

Next, you must take your desires and label them according to priority. Find a scripture that confirms that trait. For instance, if you have a desire in your top 10, you must determine what that desire has to do with Scripture. If your desire doesn't line up with Scripture, then it can't be God's desire for you.

You must be careful not to allow all your qualifications to be fleshly desires. If your list does not match Scripture, then it is too much of you and not enough of God, and that indicates you are probably not ready to date, because you have too much of you to add anyone into your life. That portion of self must die, or you may miss your opportunity. You must be willing to compromise and be prepared to give more than you are ready to receive.

I like when the Word of God says, "When you delight yourself" because God gives you the ability to be happy with you. He does this because not everyone will end up with a mate, and God didn't design us to be miserable when we don't get what we want.

It's not just being spiritual all the time. You can be you, and it's okay to be you. But while being you, make wise decisions. Don't go out making rash decisions because God gave you the ability to delight in yourself. No, He gave us the ability to live and make decisions. We not only have the ability to make decisions, we also have the ability to make wise decisions, and when doing so, we have to commit all those ways to the Lord. Only then does He give us the desires of our heart.

1. How Do You Describe a Friend?

2. What are you looking for in a friend? How many of these qualities do you possess?

3. How would someone qualify to become a part of your life at your current stage?

4. **Who are you investing all of your attention in—to the point of making them a god or expecting them to fulfill everything in your life?**

5. Where are the biggest investments you make into people? What positions do they hold in your life?

6. If you are looking for a mate list at least twenty characteristics you desire for your mate to have. Then, narrow down that list to 10 must-haves, ranked in order of priority, and find a Scripture for each to confirm these traits are Biblically sound. For married couples: Describe how your mate measures up to your original list of "must-haves."

7. **Did you use a guide to make your marriage selection choice? If not, please explain how this method could have helped you make a better choice with your decision.**

8. If so, explan how or why it helped your selection process.

10

Are Friends Important to You?

A man that hath friends must shew himself friendly: and there is a
friend that sticketh closer than a brother. (Proverbs 18:24, KJV)

A friend is very important in your life;
they give you balance more than anything else in life.

I like the part of Scripture that indicates there is a friend. This means everyone can have a friend, and there is a friend that will stick closer to you than a brother.

One thing that I require from my friends is honesty. I don't care what facet of life you serve for me, you have to be honest with me, and when I say that, I mean that. Liars suffocate me and they stop me from trusting.

The hardest punishment you will suffer in our home is for lying. My children understand that lying is a breach of trust, and once someone breaches that trust, it makes us question everything about that person from that moment forward. We will question the validity of the relationship, the sanctity of its purpose, and the conversations that were in the past. To speak the truth is hard for a lot of people, but I need the truth to trust. I may not always like it, and sometimes it will hurt, but it is a necessary part of becoming the perfect me.

You must have someone in your life that is strong enough to tell you the truth. You should never get to a place of elevation in your life where no one can be honest with you. It's just not safe. That's why friends can be so healthy for you.

Friends also hold you accountable. If you said you were going to do something, friends should be there to ask what happened. Friends keep us spiritually healthy.

Personally, I don't need people in my life who only call me when they need something. So I practice calling people when I don't need anything to remind me that relationships are more than fulfilling a need or a desire; they are to show that you care.

I also need my friends to like me. I didn't say they couldn't get mad at me. I just need them to like me.

Have you ever had a good friend that you needed and every time you call them, you get forwarded to their voicemail? And then when you leave them a message, they never call you back? If you have been found guilty of not returning voice messages, it may be why people have backed away from you. You may have inadvertently sent them a message that you don't want to be bothered.

Friends do not always need to agree with you. God will give you instructions, and you don't always need a confirmation from your friends. That may not be their purpose in your life.

A friend should complement our life rather than compete with us. A friend was not meant to replace our ability to hear God. Friends were sent to comfort us and encourage us as we follow the instructions of God.

Friends don't have all the answers for our life; therefore, they cannot give a response to every question. Sometimes our answers will just come from talking about what we are going through without them ever saying one single word.

We need to be able to describe what we are looking for in a friendship, and we must understand why friendship is important to us.

1. Are Friends Important to You?

2. Why are friends important to you?

3. Have you ever had a good friend that you needed and every time you call them, you get forwarded to their voicemail or when you leave them a message, they never call you back? Explain how that makes you feel as a friend.

4. As a friend, how would you respond to someone who avoids you?

5. Describe a time when you may have failed to be a true friend.

11

Are You Able to Supply Friends with What You Require of Them?

In desiring a friend, we have to ask ourselves if we are willing to do everything that we are requiring to develop a true relationship. Earlier in the book, we talked about what you desire from a friend. With this chapter, we have to ask ourselves if we are willing to do everything that we desire our friends to do in order to develop a real relationship.

We require people to meet certain criteria in order to become a part of our lives and to remain in a given position, but are we willing to give everything we are requiring someone else to have?

> *Be ye therefore merciful, as your Father also is merciful. Judge not, and ye shall not be judged: condemn not, and ye shall not be condemned:* **forgive, and ye shall be forgiven**. *Give, and it shall be given unto you; good measure, pressed down, and shaken together, and running over, shall men give into your bosom. For with the same measure that ye mete withal it shall be measured to you again.* (Luke 6:36–38, KJV)

My story:

Many years ago, I had a very close friend. We met in Chicago while we were being stationed there with our husbands who were in the military. We had so many things in common, and more than anything, we both were looking for a good friend. I enjoyed everything about them and their company. We went on trips together, couples dates, church events, and children play dates. We loved them and we felt their love. However, due to a disease, she fell very ill and struggled to maintain basic daily routines. So, being her friend, our relationship developed. I gave to her compassion and companionship as we worked hard to support them. I committed my time to making sure they were okay during this crisis. They were very appreciative, and from this our relationship grew even closer for many years.

113

In the mid-1990s, there was a big HIV/AIDS epidemic in America, and my brother contracted this disease. He and his young son moved in with us for support. My friend had a hard conversation with me concerning the safety of her children and how she did not want them around him. Because of this, she began to distance herself from us. As you can imagine, I lost a lot of friends due to this decision, but I loved my brother and we were as committed to him as we were to our friends. We gave him all the love and support he needed during his last days.

It was during this time that I truly needed my friends the most. But they were scared and not sure how this disease could affect people or their children, so many of them abandoned us. I never imagined what would happen next. We received a call that my husband's mother passed away. I contacted my friend and asked her to please come by and check on my brother for a few days while we went to say our last goodbye to my husband's mother. She agreed, but upon my return, I found out that my brother had been left alone for days without any support. Because my brother knew how important it was for me to be with my husband during this time, when I would call to check on him, he would say things were well and not to worry about him. He did not tell me that he was alone, he was hungry, and that he had a fall, and now he could not walk.

Upon our return home, we found out what happened to my brother, and all he could say was, "Promise me that you won't ever leave me again." I wept. I had never felt this type of betrayal before and it hurt me more than I could ever explain. After this, my brother's condition worsened, and he died only a few weeks later. As you could imagine, my relationship with my friend was severely strained and it eventually dissolved. It would be many years before we were able to reconcile our relationship, but by this time the damage had already been done. After my brother's death, God sent me a friend who was like an angel and became a big support for me. She walked into my life and helped me heal mentally and emotionally through her love. For this I am forever grateful.

With friends, we must determine what we need and be ready to accept what we cannot change.

When you are in need, do you demand what you have given to be returned with the same quality as you gave?

Being a friend can be very demanding, but if your investment is good, it should offer great satisfaction and bring great dividends. I myself have not always been a good friend, but I have learned it is better to be a good friend than to be the recipient of a good friendship, i.e., it is better to give than it is to receive. Why? Because if I can give, it is only because I have that which I can give. But if I do not have, then I cannot give, and if this is always true, it makes me needy. Giving doesn't always refer to items. What I needed from my friend was emotional support; however, she could not give me that. Relationships become strained when one person cannot give when the other needs them to.

I had a friend whom I was totally committed to. When there was a need, I filled it. When there was a request, I granted it. But one day, I had a need and I asked for help, and I was told yes, but this yes was never fulfilled. I was left alone, wounded, and very disappointed. When I approached my friend, they explained to me why they could not keep their word. To me, it wasn't good enough, and I felt used, so I withdrew from the relationship and stopped all acts of kindness and support.

Was I wrong? For me I wasn't; I felt completely justified with my response. But why did I support them? What was I looking for? Why did I feel so obligated in this relationship? Could they ever offer me what I offered them? Did I lose the true purpose of a friend? Did I give out of emotions versus supporting them out of need?

I found that we often go into relationships with expectations. We give with the expectancy that we shall receive, but what happens when we don't? Is the value of a relationship measurable with a value? Can you put a price on relationships? We often seek moral support when we don't have financial support. Keeping track of what you did or what you gave will make your friendship dispensable. The goal of a friendship is to become indispensable.

All relationships require balance, just like everything else in your life. You should not give to any one person all of you. You cannot become their god where you: supply all their needs, answer all their problems, be there whenever they need you, wipe away every tear, have answers to every question, comfort all hurt, or solve all problems. Remember, friends should become a part of your life; they should not take it over. It is okay to say no sometimes.

If someone required all of these things from you, how would you respond? Ask yourself, "Do I require many of these things from people in my life, and when I do not receive them, do I become hurt or disappointed?" Relationships were not designed to compete with God. They were designed to resemble the love of God.

1. Are You Able to Supply Friends with What You Require of Them?

2. We require people to meet a certain criteria in order to become a part of our lives or to remain in a given position. Describe what you are willing to give and what you also require.

3. When you are in need, why do you demand what you have given to be returned with the same quality as you gave?

12

Are You a Friend or a Dependent?

Before you answer this question, we must first define each. A dependent is someone who relies on others for support. A friend is a person whom you have a close bond with, a mutual affection, or a commitment.

How do you define your relationships? Are you the type of person who can find relationships with people without requiring special favors? Or are you a dependent who only find your friends according to some kind of financial, emotional, or other needed support? In other words, are you looking for relationships from those who can supply you with services to fulfill your needs?

We have all had people who came into our lives when they needed or wanted something. They were going through hard times when they came into our life but, as soon as that moment was over, they left as fast as they came. They took off with our love, emotions, and personal things. It makes us feel as if we were emotionally raped.

A man that hath friends must shew himself friendly: and there is a friend that sticketh closer than a brother. (Proverbs 18:24, KJV)

Friendships should be lasting relationships without fault, guilt, or a breach in trust. Whenever people talk about friendship in the Word of God, we refer to the relationship between David and Jonathan. Fault was never found in their relationship, and trust was never broken. When we talk about friendship that is closer than a brother, you must submit to making a commitment to create a relationship with someone who was sent into your life to help you become a better you. You must commit to friendship as you look for a committed friend.

It is really important for you to be able to identify what you offer people in relationships. If you can identify what you offer, I promise you will be able to define what you are looking for when people enter your life, and you won't be hurt by things when they happen in relationships.

1. Are You A Friend, or Are You a Dependent?

2. Explain why you define yourself: as a friend or a dependent?

3. **Are you the type of person who can build relationships with people without requiring special favors? Do you have friends who can't? Explain.**

4. Are you a "dependent friend" who only accepts friends depending on certain financial, emotional, or other needed support? Explain.

5. Are you looking for relationships from those who can supply you with services to fulfill your needs? Explain.

13

Do You Understand Why People Are in Your Life?

And **the woman said unto the serpent**, *We may eat of the fruit of the trees of the garden: But of the fruit of the tree which is in the midst of the garden, God hath said, Ye shall not eat of it, neither shall ye touch it, lest ye die. And the serpent said unto the woman, Ye shall not surely die: For God doth know that in the day ye eat thereof, then your eyes shall be opened, and ye shall be as gods, knowing good and evil.* (Genesis 3:2–5, KJV)

The Word of God says in Genesis that He created Adam and Eve and He placed them in the garden to care for it. But while in the midst of their relationship with God, they still trusted the serpent more than they trusted *His* voice.

How can we be so easily deceived?

Relationships should allow you to know the person as well as the position they serve in life. As you learn about the person, you should begin to identify the position they hold in your life. Keep in mind that people will make mistakes in life. They are not perfect, although they may be a perfect fit for your life. Regardless of your mistakes, when God called you to a position in someone's life, you were given an anointing to fulfill the duties of that position. That anointing was given to you to get them through a given situation.

God will bring people into your life to bring you comfort when you go through certain trials. God will only allow you to go through a given trial in your life after those appointed to you have arrived. While you may not understand why people are in your life upon arrival, don't be so quick to listen to the negative things people say about them. They may not know the purpose they serve for your life.

Remember when people come into your life, you should be completing assessments on them to know where they belong in your life. Your life is comprised of levels of people and hierarchy. The tighter the circle, the closer they are to your anointing. The farther away they are from the inner circle, the less distracting they

125

will become. Keeping your distractions to a minimum will help decrease the effects they have on your response to God.

You must be willing to assess people in your life to determine if they get to come closer to the inner circle or if they don't belong in the circle at all. They just may be placed on a shelf until they mature before they are allowed to come inside of your circle to intermingle with the anointing without affecting your purpose from God.

You must be sure you know the position of people in your life. This was devised so that you don't get hurt, don't wound them unknowingly, and don't cause them to stray away from God. However, if you don't know the position of people in your life, then you will not be able to discern it and could allow someone to get too close to your inner circle. They may get to see the things in your life that should not be disclosed. Some people may not be able to handle the weaknesses in your life, and disclosing these improperly could be the cause of them leaving the relationship prematurely.

How do you position people in your life?

When you try to counsel those who know too much and can't handle much, it makes it difficult to mentor them, and they reject your advice. This happens because you were not able to discern their place in your life, and now they become damaged goods. Now you've ruined a relationship without realizing it was your fault because you should not have allowed them to get that close in the first place.

You should be assessing who you are to them when they come into your life. If they came to pour into your life, that would place them in the inner circle. If they came for you to pour into their life, then they should remain in the outer realm of your circle. But too often we forget about the assessment process. We think everyone is good and safe, and we let everyone in our lives wherever they would like to go.

1. Do You Understand Why People Are in Your Life?

2. Identify why three people specifically are in your life.

3. Explain how we can be so easily deceived.

4. How do you position people in your life?

14

Are You a Giver or a Receiver in Relationships?

In order for you to truly categorize yourself as a giver, you need to be able to answer this group of questions honestly.

- Do people fail to recognize you for what you have done for them? If so, do you become offended?
- Are you disappointed with their lack of response?
- Do you talk about the situation and the people associated with the act in a negative way?
- Does your relationships with people change if they miss an important event in your life?

A receiver is one who lives life full of expectations. A receiver may say something like, "Well, it is my birthday, and I know I am going to get what I have been hinting for all year. I can't wait until my day arrives so that I can enjoy my gifts." This is the spirit of a receiver. You always want something, and you are expecting someone to do it for you.

Receivers don't want to do anything without receiving some sort of praise. Receivers will never volunteer to do anything first. Receivers are always going to be the ones who wait for someone to do the hard work and then they will go in to help. They are never going to give 100 percent because they are selfish. They often think "me first" and "mission second." They are always wanting something that someone else has, but they are not willing to work hard to get it themselves.

A giver does what God says. A receiver waits for others to do what God says.

Are you a giver or a receiver?

> But this I say, He which soweth sparingly shall reap also sparingly; and he which soweth bountifully shall reap also bountifully. Every man according as he purposeth in his heart, so let him give; not grudgingly, or of necessity: for **God loveth a cheerful giver**. (2 Corinthians 9:6–7, KJV)

People often look at themselves as givers, but really, their desire is to receive what they are giving to others.

A giver is a person who can give without expecting anything in return. A giver is a person who is willing to do without ever receiving. A giver is a person who sees a need and fulfills it. A giver is one who can hear the voice of the Lord and do what He has explained without ever questioning who the receiver is or what they possess. A giver is a person who hears from God and does not listen to the cry of people.

> *Give, and it shall be given unto you; good measure, pressed down, and shaken together, and running over, shall men give into your bosom. For with the same measure that ye mete withal it shall be measured to you again.* (Luke 6:38, KJV)

God's word explains clearly to us the process of giving. As you give, He will give back unto you. It's the process of supply and demand. But when you learn to walk in total obedience to God, you don't have to ask when you are in need; it is done automatically by the Lord. He promised to supply you with the same measure that you meet. Now does this mean that you should give everything you have to anyone that you meet? No, you still should be led by the Spirit of God. God doesn't want us to be their supplier and to satisfy their every desire. He wants them to go to Him first. When they go to God, He calls us by name to do as He has commanded. So we don't work of our will, but off the will of the Father who has sent us.

1. Are You a Giver or a Receiver in Relationships?

2. **Describe one example of a giver and one example of a receiver in your life. Which of these examples of their traits resemble you more?**

3. **Do people fail to recognize you for what you have done for them? If so, do you become offended? Explain.**

4. **Do you talk about events and the people associated with their reactions in negative ways? Explain why.**

5. **Does your relationship with people change if they miss an important event in your life? Explain why.**

6. God promised to supply you with the same measure that you meet. What does this mean to you?

15

Can You Handle Honesty?

It is very difficult to help someone grow without describing to them some of their shortcomings. Yes, the truth may hurt, and the truth may be offensive, but is hurt necessary for you to grow? When God sends someone to help you, make every attempt to receive their constructive criticism rather than critiquing their method of delivery. Most people respond to you in the same manner in which you communicate with others.

In life, you cannot treat everyone the same because people come from different worlds, with different issues, and for a different purpose. Some people must be handled very gently and with care. If handled improperly, they could become spiritually injured and, as a result, leave your life.

Then you have another group of people who may come from the school of hard knocks and take gentle as passive. This group of people may become dominating in your life and prevent purpose from being birthed. With dominating people, you may have to be upfront and direct in order to maintain clarity.

Finally, there are those who take criticism and being critiqued well. This group of people often grow like wildflowers. They understand the process of tough love. They understand leaders are not doing what they do to gain power or control over them but to help define and bring transparency into their life.

You may identify yourself as one who is easily offended

- if you cannot take being critiqued;
- if you have had multiple failed relationships, and they all have similar complaints about your character;
- if you must give an explanation for every failure in your life;
- if you move from church to church because you find fault in every place you have attended;
- if you have had numerous jobs because you find it difficult to get along with people in close confinements or you cannot handle being told what to do; and

- if you move from friend to friend because everyone you meet has issues, which causes no one to ever stay permanently in your life.

> **In the day of my trouble I sought the Lord**: *my sore ran in the night, and ceased not: my soul refused to be comforted. I remembered God, and was troubled: I complained, and my spirit was overwhelmed. Selah.* (Psalm 77:2–3, KJV)

When you hear words used to describe you, how do you respond?

- Sit quietly and listen to gain understanding of how your character is viewed?
- Become easily angered and respond with harsh words of resentment?
- Cry with tears of failure because you feel as if you have tried so hard to make people like you?
- Walk away to regain your composure because if you would respond, you could not control the words that you would release?

> *For with what judgment ye judge, ye shall be judged: and with what measure ye mete, it shall be measured to you again.* (Matthew 7:2, KJV)

Having your character judged can be very difficult, but to become a better you, you must practice to become slow to speak and quick to listen. You have to accept that you don't know what you don't know. How can you learn unless you are taught? Let's observe and take what is good and profitable for our soul and reject what is not.

1. Can You Handle Honesty?

2. How do you think hurt affects your growth?

3. Evaluate yourself to identify if you are easily offended. How do you handle being critiqued?

4. Explain your failed relationships that have similar complaints about your character.

5. **Do you give an explanation or reason for every failure in your life? Why or why not?**

6. **How many churches have you moved from because you find fault in where you attended? What was that fault and why did it cause you to leave?**

7. **How many jobs have you left because you find it difficult to get along with people or because you cannot handle being told what to do?**

8. How many friends have you gone through because of their "issues"? How many have remained in your life permanently?

9. When you hear words used to describe you, how do you respond?

10. **How do you gain understanding of how your character is viewed by others? Do you become easily angered? Do you respond with harsh words of resentment? Do you cry with tears of failure because you feel as if you have tried so hard to make people like you? Do you walk away to regain your composure because if you would respond, you could not control the words that you would release?**

16

Are You Aggressive in Finding Friends, or Do You Wait for Others to Invite You into Relationships?

This is the introvert versus the extrovert, but do you recognize which one you are? An extrovert prefers companionship and does not have to ask for friends because people are often drawn to their outgoing personality. They find friends everywhere they go, and no one is a stranger. Introverts often sit back and wait for an opportunity to be introduced. Introverts are usually people who pay attention to their environment and see everything. Extroverts may have more fun, but they often overlook delicate details. Extroverts usually don't pick their friends; people choose them. They are usually social butterflies, so they are always going into the next relationship as they enjoy the moment.

You have to know who you are so that you are able to adapt to people when you are in their presence. If you are in the company of many people and you find yourself apologizing to a friend for ignoring them, you may have extrovert tendencies. If you are the person who entered the party with a friend, but you end up sitting at a table by yourself, waiting for someone to come and talk with you, you may have introvert tendencies.

In our home, I am the social bee. When I enter a crowded room, I want to greet everyone I can, if only for a second. My husband, on the other hand, is a total introvert, and it takes an act of Congress to get him to socialize past the first table of people that engage him with an intelligent conversation. He is that person who will sit on the back row of the church and leave right after church service without talking to anyone. He requires his personal space, and he must be given those moments to regroup and be all by himself.

It took me many, many years to understand how different we actually are. Where I require people to be in my presence to enjoy life, he needs people to leave his presence so that he can enjoy his life. For years, I could not understand why he wanted a room for himself. To me, that was just selfish because I did not understand

or respect his personality. It wasn't until we moved into a home and we were able to build him a man cave that our marriage developed to become a place where we were happy more than we were in lovers' quarrels.

His character requires him to have his alone time to regain his composure after being engaged with people all day. After work, he needed to get home and away from people before he was able to enjoy me or our children. Without understanding this, I would bombard him when he came home to talk to me, but all I would get from him was the silent treatment. As you can imagine, as an extrovert, I would try to be a problem-solver by asking if there was something wrong or if he had a bad day, and yes, you can imagine that this environment created arguments over nothing.

I finally realized that different requires different. I could not make him like the things that I like because he was made so different from me. After all, statistics show that most men run out of words quickly, whereas we as women can talk to friends for hours, and then call them when we get home from an event just to say how much we enjoyed our time.

1. **Are You Aggressive in Finding Friends, or Do You Wait for Others to Invite You into Relationships?**

2. **How long should you wait for an invite into a relationship? If you are aggressive, when should you pull back?**

3. **Are you an introvert or an extrovert? Explain how you know and why.**

17

What Is It About You that Annoys People?

Now this is a deeper question, because I know that we can get really spiritual when we begin to identify the things in us that may be offensive. So I will refer to Scripture to identify how we should describe ourselves in this section.

> And lest I should be exalted above measure through the abundance of the revelations, **there was given to me a thorn in the flesh, the messenger of Satan to buffet me**, lest I should be exalted above measure. For this thing I besought the Lord thrice, that it might depart from me. And he said unto me, My grace is sufficient for thee: for my strength is made perfect in weakness. Most gladly therefore will I rather glory in my infirmities, that the power of Christ may rest upon me. (2 Corinthians 12:7–9, KJV)

Isn't it amazing how God can do things to keep you from being conceited? He puts a thorn in your flesh, a messenger of faith, in our life to keep us under control because when left to our own devices, we can destroy ourselves.

Some of us become great in life and believe that no one else is qualified to fit into our greatness. Some of us get a little higher up in life and believe we are now qualified to counsel and teach everyone around us. God has to tame us, so He brings vices into our life to remind us that we are not there yet. It's not until you really get into the holy of holies that you can say as Samuel said:

> Behold, here I am: witness against me before the LORD, and before his anointed: whose ox have I taken? or whose ass have I taken? or whom have I defrauded? whom have I oppressed? or of whose hand have I received any bribe to blind mine eyes therewith? and I will restore it you. And they said, Thou hast not defrauded us, nor oppressed us, neither hast thou taken ought of any man's hand. And he said unto them, The LORD is witness against you, and his

anointed is witness this day, that ye have not found ought in my hand. And they answered, He is witness. (1 Samuel 12:3–5, KJV)

The Word of God is so true, isn't it? It's the Word that keeps you balanced to make sure that you don't get out of control. God cannot use people whom He cannot control. God will terminate His purpose with anyone who lacks the ability to control themselves. God won't use anyone who cannot discipline their flesh, regardless of the anointing they may carry. You must be able to control your emotions, and you cannot allow your flesh to respond to people who annoy you by becoming a constant complainer.

If you don't know what you do to people that annoys them, you are probably going to do it again. Eventually, the annoyance will grow into dislike. So it is really important to listen to what people say and even more to what they don't say. Body language can also help you learn when annoyance arrives.

The anointing lives on the inside, and it will chasten you to adjust when needed. When you do something that's not right, at the end of the day, you may have a moment of reflection, and everything you did that was not right will come back to you. These are moments when you say, "You know what? Maybe I should not have done that. I could have said that differently."

I use to annoy people a lot and didn't know it, until one day, I had a talk with a choir member. When I would get excited, I would hit people on their backs with a loud laughter. I saw it as a friendly gesture. But what I didn't understand was some people thought I hit too hard and too often to ignore it. After a few hits, my gestures became quite offensive.

Because of my inability to read body language and even after people would say, "Stop hitting me," I still continued until I hit a mother in the church choir.

One day, I was with a group of people talking, laughing, and having a good time, and then excitement came and I hit the mother on her back. That mother grabbed this five-foot-ten girl and put me in chokehold. As everyone looked on in laughter, I could tell she meant it when she said, "Don't hit me like that again." Then I got it. God allowed me to be chastened because I did not learn how to read people. I needed to learn my boundaries, and enough was enough. These are words of wisdom, and it will help you build healthy relationships.

We usually don't learn how to read people, so we get chastened through their anger, and when that happens, it really hurts.

Have you ever had one of those moments?

Can you list five things about you that annoy people?

The people in your life today can be the people in your life tomorrow, but if you don't adjust, the people in your life today may be absent in the future when you need them the most.

Some things about you may be a part of your character, and you can't change character. You are what God wanted you to be, but some habits should be adjusted. For example, I am very bold, and I believe that is how God wants me. Where I can't change my boldness—because that is a part of my character—I can change the volume in which my boldness is expressed. You have to know what you should change and what could be altered. You have to have balance because you don't want to lose yourself in satisfying others. God will help you identify those things in your life that are weak and let you know that perfect is not who we are; it is what we strive to become.

1. What Is It about You That Annoys People?

2. What does God use to keep you from being conceited?

3. Describe a moment when you were chastened through someone's anger.

4. List five things about yourself that annoy people.

18

How Long Does It Take for You to Forgive Someone Who Has Disappointed You?

When you are expecting things from people and you have an anticipated arrival of something you desire, that expectation will create an opportunity for you to be disappointed. You will begin to feel like you deserve things and develop a must-have-it attitude. When this happens and you don't get your desire satisfied, you may begin to harbor bitterness, anger, and resentment. There will be times when these moments can go on for days, weeks, or much longer. How long does it take for you to forgive someone who disappointed you?

> No man can enter into a strong man's house, and spoil his goods, except he will first bind the strong man; and then he will spoil his house. Verily I say unto you, **All sins shall be forgiven unto the sons of men,** and blasphemies wherewith so ever they shall blaspheme: But he that shall blaspheme against the Holy Ghost hath never forgiveness, but is in danger of eternal damnation. (Mark 3:27–29, KJV)

Once the enemy comes in and binds the strong man, he can spoil everything else in his home. In this case, what is the strongest thing that can be possessed? It is the mind, which can be controlled through our thought process. The mind is the strongest entity of a being.

Whatever controls your mind also has the ability to control your heart, and the heart holds your emotions. The mind governs your decisions, and it controls your ability to surrender totally unto God. Your mind regulates your will. So if the mind is under control, then everything in you can be spoiled by whatever controls it. You are dominated by the things that dominate your thought process.

This concept is powerful because it helps us understand how the enemy operates. He can take our strengths and make them wicked to destroy the things we really wanted to happen. Isn't that crazy? In order for us to shift the dynamics in our life

that control us, we must replace the dynamics that control us with the Word of God, and that will change everything we think. All we need to do is change our thought process. By changing our thoughts, we can process the things in our life as they are presented to us, which then gives us the power to live, laugh and to forgive, which we need the most.

Some people say, "I forgive you," but yet there is still some unforgiveness and resentment they hold on to because they may hold you to a certain standard.

So how many times do you forgive? If we have the one-strike rule, then God has the right to have that same judgmental attitude with us.

For instance, if you sin and God forgives you, we expect God to also forgive us for our next sin, right? But in reality, are we casting judgment in the same measure with which God judges us?

If we are expecting God to forgive us, then it's mandatory that we forgive others.

You have to forgive without holding on to unforgiveness. We forgive with our speech, but in our heart, we never let it go. We often feel justified in having these emotions.

When a person commits adultery and the relationship is restored, why do we accept the person but we deny them trust? This is an example of unforgiveness. If you have to check behind their every move, you don't trust them.

Life and relationships should be enjoyed. Sometimes, things are going to be really good, and sometimes things are going to be really bad, and you'll want to disappear. But that's life. In relationships, you are either going to trust or choose not to trust, and then proceed with your course. In unforgiveness, we tend to blame the person, forgetting that our flesh is weak too, and without God, it is impossible to control our flesh.

It's not about the man; it's about the God in the man. The man has no ability to keep himself; that's what God is for. The Holy Ghost said I will give unto you power. We all need that power to overcome temptation.

I do not believe the flesh has the ability to do any good thing without being able to hear God. If you don't have any convictions, you do not have any boundaries.

Without God leading and guiding you, that means it's just you, and that's a scary thing. When you have a person that knows God, they don't have to live a super, power-packed life, speak in tongues, slay demons, or attend church every day. They don't have to have the same relationship with God as you have. All they need to have done is accept Jesus as their personal Lord and Savior. That's enough for me because the Word of God says immediately, the Lord dwells within us when we accept Him as our personal Lord and Savior. Then God will speak into the heart of the man or woman.

We must learn to take what we cannot fix to God and leave it there. If you are going to forgive, forgive and let it go. If you are not able to forgive, then maybe it's time to walk away. Nobody wants to live in your captivity.

Forgiveness is a hard thing, but so is life. Life says that you have to live, love, and forgive over and over. People are going to come in your life, and they may hurt you in the same way that someone else hurt you, but you have to learn how to forgive, regardless of what you have been through.

1. How Long Does It Take for You to Forgive Someone Who Has Disappointed You?

2. **When the enemy comes, what is the strongest thing in you that he can possess?**

3. How many times will you forgive a person?

4. **Are your casting judgments with the same measure with which God judges you? Explain.**

5. **When a person commits adultery and the relationship is restored, why do we accept the person but we deny them trust?**

6. What dominates your thought process?

19

Do People Enjoy You, or Have They Just Learned to Tolerate You?

> *We get so consumed with our condition*
> *that we forget to listen to instructions.*
> —Apostle Randy Roberts

I have had people in my life whom I did not always enjoy, but I had to learn how to tolerate them for ministry's sake. I am not sure whether God put those people in my life to get them through certain things or whether the situations were something I created on my own.

There were relationships that were one-sided, and I knew they weren't going to be enjoyable, but I just had to make things happen.

> *And Laban said, It must not be so done in our country, to give the younger before the firstborn. Fulfil her week, and we will give thee this also for the service which thou shalt serve with me yet seven other years. And Jacob did so, and fulfilled her week: and he gave him Rachel his daughter to wife also. And Laban gave to Rachel his daughter Bilhah his handmaid to be her maid. And he went in also unto Rachel, and **he loved also Rachel more than Leah,** and served with him yet seven other years. And when the LORD saw that Leah was hated, he opened her womb: but Rachel was barren. And Leah conceived, and bare a son, and she called his name Reuben: for she said, Surely the LORD hath looked upon my affliction; now therefore my husband will love me. And she conceived again, and bare a son; and said, Because the LORD hath heard that I was hated, he hath therefore given me this son also: and she called his name Simeon. And she conceived again, and bare a son; and said, Now this time will my husband be joined unto me, because I have born him three sons: therefore was his name called Levi. And she con-*

ceived again, and bare a son: and she said, **Now will I praise the LORD: therefore she called his name Judah;** *and left bearing.* (Genesis 29:26–35, KJV)

Although Leah did everything she could to please her husband, she was tolerated but never loved. However, the Word of God says Leah did everything right. Being tolerated doesn't mean you did something wrong; it just means you may not be appreciated.

I like the Word of God when it says Jacob loved her, but not as much as he loved Rachel. In other words, he did have some affection for Leah, but not like he loved Rachel. Jacob was forced to accept something that he had no say over in order to get what he desired.

That's how relationships work when you are forced to be in something you don't desire; causing you to become so bitter you learn to hate, and the person you're with feels it the most.

The Word of God says Leah got to a place that it wasn't about him or her anymore. She said, "God, this is about me and you. You gave me these children. I know that I am a blessed woman, and I've done everything I know to do. So you know what? God, I'm just going to worship you." We know that her heart changed because her next child's name was Judah, which means "praise." The Lord desires our worship, and you have to learn how to worship Him through your struggles.

1. Do People Enjoy You, or Have They Just Learned to Tolerate You?

2. If people are simply tolerating you, how does that make you feel?

3. **How do you worship God through your struggles?**

20

Are You Trustworthy, or Are You Secretly Waiting to Betray Others?

You shared an intimate secret, and then all of a sudden, it appears on the gossip blotter. We know about these relationships, right? Isn't it amazing how secret conversations can destroy one's reputation? We must be honest with ourselves and realize that not everyone can take us in our personal, revealing moments. The truth is, people will judge you by the moments you share with them without realizing it took a lifetime to get there. People will hear things and judge you according to one moment in time without knowing your history. When you judge conversations independent of their history, you take away from a person's character.

We all have the ability to understand betrayal, but we don't realize how deeply betrayal kills trust. Once you've slandered someone's reputation, it is not easily restored. It takes so long to recover from a defamed moment, and for many, they won't ever be fully restored. You must be very selective with whom you choose to share sensitive information. You must be sure that person is strong enough and solid enough to be able to handle your transparency.

Some moments will not require an answer; you just need someone to listen and not be judgmental. There are times when you just need to scream. There are times when you just need to vent without barriers. But remember, betrayal isn't always started with intentional acts; it starts with secrets, with private moments shared.

How do you trust, or can you be trusted?

> *The thing that annoys you the most*
> *shows that you have the power to change it.*

These are self-evaluations that we must ask ourselves. Can I be trusted? You must be honest with yourself. What type of person are you on the inside? Do you get angry with people who share secrets from someone else? Do you enjoy listening to things about people when it does not concern you? If someone confides in you, can

you be trusted with what you have been given? Have you ever told someone else's secret? Can you take what was shared privately and hold on to it, even though you may not agree? Or are you the type of person who believes that you can share information secretly with others because it won't ever be shared again? Have you ever said to someone, "Let me tell you what they said." If any of these apply to you, then you must ask yourself, "Can I be trusted?"

People love to talk. Sometimes people talk just to hear their own voices. People will talk to you, and you may find yourself speaking without direction until, eventually, you start talking about the people who came into your life to assist you. As we all know, gossip always gets back to the innocent person, and you can ruin a good relationship as a result.

This could be a reason why people fail to have long-term relationships with you. Could it be due to the things you may have said that were just not right? When you know certain people are in your life, you have to trust they are who God has showed you they are, and not the things people have spoken to you about them.

Can you trust others after you've experienced betrayal in a relationship?

Have you had a friend who broke off a relationship with you after sharing differences, and then out of nowhere, they became your worst enemy? Now because you have been hurt, you have learned how not to openly trust anyone. And when things don't go well in a relationship, you turn your back on people in the blink of an eye because you have learned that friends cannot be trusted beyond what you can see or witness. With this type of behavior, can you see how this type of attitude could make people not like you?

> *The good man is perished out of the earth: and there is none upright among men: they all lie in wait for blood; they hunt every man his brother with a net.* (Micah 7:2, KJV)

Why does the good man perish? He perishes because of people's inability to release him from his past even though he is no longer the man of his past. Whether the good man is a woman or a man, whether that good man was your ex-husband or a boyfriend that departed from you, whoever that person may be, we are referring to someone of integrity who perished out from the earth because of a bad judgment call. We all have some things that we struggle with. Micah says, "There is none upright among men," which means you have issues and hang-ups in your life, too.

> *Death and life are in the power of the tongue: and they that love it shall eat the fruit thereof.* (Proverbs 18:21, KJV)

Words that we release from our mouth are powerful. They have the ability to create life and to produce death. We must guard what we say because things happen when we speak.

What you say, you create.

What you create, you eat.

What you eat is what you produce.

And what you produce is what will nourish you.

God said, "With the same measure that you judge, you shall be judged." I took these words lightly until I decided to test them to see if God operated in this method. Boy, were my results confounding! The same thing I did to someone was the very same thing that came directly back to me, but it hurt so much more. Why did it hurt more? Because I understood what God said, and I still decided to test God's tolerance.

Whatever you birth is always bigger than the seed that produced it. It is so true when the Word of God says, "With the same measure." When you inflict revenge on someone, it often feels good for a moment. The feelings of satisfaction will lessen, and the results of your action will worsen with time. When you can ask yourself, "How long do I have to suffer?" the results of your actions are only beginning to come to an end.

1. Are You Trustworthy or Are You Secretly Waiting to Betray Others?

2. Explain how secret conversations could destroy one's reputation.

3. How do you trust?

4. **Why do you think you can be trusted? If someone confides in you, can you be trusted with what you have been given? Can you take what was shared privately and hold on to it, even though you may not agree?**

5. What type of person are you on the inside?

6. **Do you get angry with people who share secrets from someone else? Do you enjoy listening to things about people when it does not concern you? Explain.**

7. **Have you ever told someone else's secret? Who do you confide in when you are holding secrets?**

8. Have you ever said to someone, "Let me tell you what they said!" Do you think that you can share other people's secrets privately because they won't ever be shared again? If either of these apply to you, you must ask yourself again, "Can I be trusted?"

9. How do you trust others after you've experienced betrayal in a relationship?

10. Have you had a friend who broke off a relationship with you after sharing differences and then out of nowhere, they became your worst enemy? Describe how that made you feel.

11. Why does it hurt more when things are done to you, than when you do things to others?

12. How long do you have to suffer after a betrayal? How long do you require people to suffer after they betrayed you?

21

How Many Times Can a Person Hurt You Before You Walk Away?

Write this question down because I know many of you will respond with an answer that will require repentance later.

Some of you may make this statement, "You only have one time to hurt me, and it is over." If you are one of these people, I must say this: you are not fit for ministry. Why do I say this? Ministry hurts. You must be willing to forgive and then be willing to be hurt all over again. Only then are you suitable to walk in the ministry of reconciliation and second chances.

> Then came Peter to him, and said, Lord, how oft shall my brother sin
> against me, and I forgive him? till seven times? Jesus saith unto him,
> I say not unto thee, Until seven times: but, Until seventy times seven.
> (Matthew 18:21–22, KJV)

This was personal when Peter asked, **"How many times am I supposed to forgive?"** He knew God as a forgiving god, a god of new beginnings, and a god of second chances, but he needed to know how many times *he* was expected to forgive. What Peter was trying to do was to get Christ to identify what was required of him as a Christian.

Forgiving someone who hurt you is very difficult. A deaconess in our church would often say, "This isn't for the weak. You have to be strong in this fight." This is such a prophetic saying because you have to be so much stronger mentally than you ever have to be physically. Physically, I can do many things, but mentally, that's a different story. There is an unexplainable hurt that happens when you are rejected. Even though your intentions were from the heart and you tried to do the will of God, it's a wound that can only be identified by those who have experienced rejection.

How do you fix hurt?

The person who hurt you may say, "I didn't mean to hurt you. It was never my intention." But the fact of the matter is, they did hurt you. Peter asks how to deal with this. Christ goes on to teach Peter how to walk in ministry. We all must learn the forgiving part of ministry to be effective for the kingdom.

My true mission in ministry is with women who have been hurt and broken and now desire to become great. The women whom I work closely with will never be the same when they leave my life because God gave me this ministry. However, I had to understand that hurting people will strike to hurt those who were sent to help them because they themselves are hurting. This is all a part of ministry, and if I want to be a women-changer, I must be willing to be hurt, be ready to forgive, and give them another chance. In order to fix your hurt, you must be willing to forgive people while allowing them to remain a part of your life. If you don't get to that point, you are not going to move forward in life.

If you don't heal from your past hurt, your children are going to have your internal hatred and bitterness, which will eventually be used against you. I have a saying: once you have taught a child how to do something, you can never control how they use it.

1. How Many Times Can a Person Hurt You before You Walk Away?

2. **Do you struggle with this question, "How many times am I sup-
 posed to forgive?" Explain.**

3. **How do you fix hurt?**

4. **Once you have taught a child how to do something, you can never control how they use it. What have you taught that you now regret?**

22

How Do You Define Success?

*This book of the law shall not depart out of thy mouth; but thou shalt meditate therein day and night, that thou mayest observe to do according to all that is written therein: for then thou shalt make thy way prosperous, and then **thou shalt have good success.** Have not I commanded thee? Be strong and of a good courage; be not afraid, neither be thou dismayed: for the LORD thy God is with thee whithersoever thou goest.* (Joshua 1:8–9, KJV)

What is success?

My husband and I met a very wealthy man who learned of some of our endeavors in ministry. After meeting, he said to me, "They must really consider you to be successful where you come from," as if to say we were not. That was baffling to me. I thought, *Where does he think I come from?* Then I realized that to him, success was wealth and possessions, and if we possessed expensive things, that meant we were successful. We did not appear to him to be successful because he did not need what we had to offer.

People will appreciate your gifts according to how much they need you. People who are attracted to your gifts may view you as successful, but people who do not need your gifts may never notice your existence. Success should be an internal accomplishment of doing what God has instructed. Due to your obedience, people will rise from their failure and into success. Through your accomplishments, people hold the ability to overcome defeat and commit to change. That's where success is viewed in my eyes. So how do you define success?

How do you prepare to bring people into your life?

When people come into your life, what do you want from them?

Why are they in your life?

How do you treat them when they arrive?

Success has nothing to do with wealth in the way that most people see it. Success has to do with a wealthy mindset that changes the way we receive from God. We can

be content because we understand that God has us in a place where we must remain focused on what He desires from us. The Word of God describes progression as success. Progression means we are consistently moving forward. You must stay focused on God and He will make your way prosperous.

Success is…
when you are able to become you
without becoming the person you resent.

1. How Do You Define Success?

2. How do you prepare for people to come into your life?

3. When people come into your life, what do you want from them?

4. What are you prepared to offer them?

5. How do you treat people when they arrive in your life?

23

Do You Struggle with Jealousy?

Have you ever dedicated your time to accomplish a goal and no one recognized your accomplishments? It's like graduating from high school and no one attended graduation. How would that make you feel? How does it feel to become great and no one ever knows what you achieved?

When people do great things, do you find yourself praising them by saying, "I am so proud of you!" or do you find yourself asking, "Why haven't I been able to accomplish that?"

I have to understand and realize this walk isn't about me. This isn't what I chose to do. I am just following God's instruction for my life. The Word of God says great gain comes with contentment, so in whatever state I am, I must remain content.

> *Not that I speak in respect of want: for I have learned, in whatsoever state I am, therewith to be content.* (Philippians 4:11, KJV)

You cannot define what God has designed because His ideas are not based upon your creation. It was determined when you said *yes*.

In life cycles, we have phases we must go through. In every stage of life we enter, if you find yourself saying, "Why not me? Why can't I go there? Why can't I go through this? Why can't I be great?" then you must also ask, "Do I see any good thing in myself?"

What kind of person are you that you find yourself always comparing your life to someone else's accomplishments? Where does this put you as a person? When do you take the time to say to someone, "You are doing a great job, and I am so proud of you"?

These are questions we have to ask ourselves because in true relationships, you need to step out of the way when someone else is doing something great and say, "It's their time."

> *For we ourselves also were sometimes foolish, disobedient, deceived, serving divers lusts and pleasures, living in malice and envy, hateful,*

and hating one another. But after the kindness and love of God our Savior toward man appeared, not by works of righteousness which we have done, but according to his mercy he saved us, by the washing of regeneration, and renewing of the Holy Ghost; which he shed on us abundantly through Jesus Christ our Savior; that being justified by his grace, we should be made heirs according to the hope of eternal life. (Titus 3:3–7, KJV)

I like this scripture because it states, "For we ourselves *were*," meaning in our past. Sometimes the first thing we talk about is foolish, then disobedient, and then, finally, deceitful.

Not everyone will hear from God at the same time or in the same method. So we are going to have times when God speaks to us and we will wonder, *did we miss God?*

When God gives us favor, it looks like an orchestrated plan. That's why it is important that we give applause to others' performances in life and recognize what they are doing because our turn is coming, even if we do not understand His process.

I have to listen to my daily instruction; I can't get so focused on what I want to do that I can't hear God. People have to be in order in your life, and they must go in order to give you access to your promises. Some things cannot happen until you get in place, the person assigned to you gets in place and the right opportunity arrives. As soon as they get in place, God says, "It's your turn," and immediately you have access.

God is putting people in place, and He is going to give you access, but your access is not yet available because people are not lined up. So we can't look at what people are going through and what they are receiving or what we are not getting. We must remember to rejoice in the things that require an applause and realize that our season is coming. However, if you don't take a moment to recognize people who are having their season, then your moment can't arrive.

God needs to know that he can trust that you can handle success without pride or jealousy, so he exposes your hidden weakness. These challenges are put before you to help you define you.

Jealousy is the opponent that prevents you from celebrating greatness. Jealousy is developed when you lack the ability to recognize that God has time designed to perfect you. With growth and development, you will obtain great things through the journey of life.

Every portion of your life was designed to create a strength within you that will be required for you to use in your future. Without struggling, without failures, without rejection, you will not develop the strength needed in your future that can only be developed through pain.

1. Do You Struggle with Jealousy?

2. Explain your struggle with jealousy.

3. How does it feel when you are not recognized for your accomplishment?

4. **How would you handle becoming great and no one ever knowing what you've achieved?**

5. When people do great things, do you find yourself praising them by saying, "I am so proud of you!" or do you find yourself asking, "Why haven't I been able to accomplish that?"

6. **Do you go through stages of life saying any of these things: "Why not me?" "Why aren't things happening for me?" "Why can't I go there?" "Why can't I get through this?" "Why can't I become great?" If so, what phase of life's cycle do you believe you are going through?**

7. Name at least five good things you see in yourself.

8. **Do you find yourself comparing yourself to the accomplishments of another? Where does this put you as a person?**

24

Do You Start New Things with Good Ideas yet Rarely Finish?

I wisdom dwell with prudence, and find out knowledge of witty inventions. (Proverbs 8:12, KJV)

How often do we have great ideas? I have had some great ideas in my life that could have made me a millionaire today. But what do I end up doing with those ideas most of the time? Nothing. My response is usually that I don't have time, or I will do it later.

What did I just do? I ignored greatness. Greatness is not something you are born with; greatness is something that is developed.

There are several types of people in this category. There are people who, like our example, have great ideas but put everything off until later—which most times never happens. There are people who will only accomplish what is spoken to them verbally because they lack the ability to hear God for themselves. Then there are people who do not believe they possess any great ability and will push everyone to their vision, while failing at every promise given to them by God.

What kind of person are you?

> *Rise ye up, take your journey, and pass over the river Arnon: behold, I have given into thine hand Sihon the Amorite, king of Heshbon, and his land: begin to possess it, and contend with him in battle.* **This day will I begin to put the dread of thee and the fear of thee upon the nations** *that are under the whole heaven, who shall hear report of thee, and shall tremble, and be in anguish because of thee.* (Deuteronomy 2:24–25, KJV)

Now this is some kind of favor when God will cause people to fear your name. They are not going to fool with you because they know that you have the favor of God on your life.

I like to study the days of the Old Testament because God was so real with His people and He was so prevalent in their lives that when the anointing and the covering of God were with them, it was obvious. It was evident that they were appointed to be wherever God placed them. It was evident they had the favor of God over their life. Who can come against those who fall on their knees in the presence of the Lord? In the Old Testament, they reverenced God and the power of His name.

Today, I think we get to the place of fear, and we forget to reverence our Lord. We forget the power that we receive when we are with Him. Just being in His presence will cause us to automatically fear Him, but it takes submission to give Him reverence.

When I walk into a room, I expect people who are not living according to God's instructions to be uncomfortable. They should feel a little antsy. Not that I believe that I am all that, but I carry His anointing and His favor. No one should feel okay to disrespect the anointing that I carry in my presence.

One day, I was driving through a parking lot with my daughter. We had our windows down as we passed by a young man talking on his cell phone. He started cursing, but then looked directly at me and immediately said, "Ma'am, I am sorry. Forgive me. I am so sorry." My daughter looked at me and said, "Mom, what is he talking about?" She did not understand his apology because she didn't realize he was giving reverence to the anointing I was carrying.

That's reverence. That's authority. He wasn't responding to me. He gave reverence to what I was carrying. You should not be okay with those who would do or say whatever they desire in the presence of our God. The presence of our Lord should make you say, "Wait a minute, this is not a good thing to do. This is not an appropriate place to behave that way." Just think, your next action could be the reason you are stricken with something. That's how things went in the Old Testament days.

When it comes to doing things for God's people, we should do it with an attitude that we cannot fail. If we do what God instructs us, then it is not our idea. We are only following His instructions, and He will never fail at anything. My responsibility is to listen closely and do exactly as I am told.

> *Then they told David, saying, Behold, the Philistines fight against Keilah, and they rob the threshing floors.*
> *Therefore David enquired of the LORD, saying, Shall I go and smite these Philistines? And the LORD said unto David, Go, and smite the Philistines, and save Keilah.* (1 Samuel 23:1–2, KJV)

David was counted as righteous because he realized he could not win the battle in his own strength. Before David led his people into battle, he sought God's guidance. His questions were simple: Lord, do we stay, or do we go to battle? Then David waited on God's response.

How often do we wait for God to respond to our requests?

We should develop an attitude of not moving until the Lord speaks, and once He does, we move exactly how He instructs without hesitation.

I like the Old Testament because God's people often received quick answers and instructions when they prayed. So I ask, What happened to our ability to hear God?

We complain that we cannot hear God's voice today even though Jesus died and left us with the Holy Spirit to dwell as a guide unto all truth. The people of old did not have the Holy Spirit to commune with, talk with, or guide them. They could only hear God's instructions through a priest, yet they believed. We have the power to communicate with God through the Holy Spirit, but we still say that we can't hear God. I challenge that!

I challenge that because the Holy Spirit allows us to hear directly from God. So we must ask ourselves why we have failed.

We know from the Word of God that we can do all things through Christ who gives us strength. If this is true, then we cannot fail. So it must be that we just won't commit to what we have started. We shouldn't be asking if He's failed us. We should wonder if we have failed Him.

When we fail to finish what we were instructed, we may be in danger of losing our country due to disobedience. When we talk about our country, we are not referring to the United States; we are talking about our family as our region. Disobedience can cause you to lose your whole family.

> *Keeping mercy for thousands, forgiving iniquity and transgression and sin, and that will by no means clear the guilty; visiting the iniquity of the fathers upon the children, and upon the children's children, unto the third and to the fourth generation.* (Exodus 34:7, KJV)

Think about how many times generations were destroyed because of the acts of one person. The Word of God says they were cursed to the third and fourth generations. One person brought on a root of bitterness from God that caused generations to suffer. Could that be you? Why are so many things not lining up?

> *If ye will not hear, and if ye will not lay it to heart, to give glory unto my name, saith the LORD of hosts, I will even send a curse upon you, and I will curse your blessings: yea, I have cursed them already, because ye do not lay it to heart.* (Malachi 2:2, KJV)

Our inability to finish our assignment gives authority to the enemy to control his domain. Remember, whatever you overcome in life, you conquer in the spiritual realm, and whatever you conquer, you control. But when you don't have the ability to conquer, you lose the ability to control, which means someone or something else will always dominate you.

1. Do You Start New Things with Good Ideas Yet Rarely Finish?

2. **How often do you start new things with good ideas but not finish them? What do you need to do to fix this?**

3. **How often do you have great ideas? List at least three ideas you have had over the past year. What have you done with them?**

4. How long do you wait for God to respond to your requests?

5. How would you rate your ability to hear God?

6. Looking at the sin in your life, could your root of bitterness be the result which could cause your generations to suffer? What is your affliction toward God that will cause generations to suffer?

7. **Why are so many things not lining up in your life? How would you fix this?**

25

Do You Respect People, or Do You Respect Positions?

*Thou shalt not wrest judgment; thou shalt not respect persons, neither take a gift: for **a gift doth blind the eyes of the wise, and pervert the words of the righteous**. That which is altogether just shalt thou follow, that thou mayest live, and inherit the land which the LORD thy God giveth thee.* (Deuteronomy 16:19–20, KJV)

The Word of God says not to have respect of persons, but we should respect their anointing. The anointing comes with an appointment. When God calls us, He anoints us to complete an assigned task. This is a position that you hold. It is not who you are; it is simply what you have been given to do. When you see people in high positions, such as the President of the United States, they are anointed to hold that position. Your pastor is anointed to fill their position. Your mother and father were anointed to fulfill the position as parents for your life.

We often look at people who are making decisions on our behalf, and we believe we could make better decisions, but can we? Could you make the types of decisions they are making under the intense pressure they face? I am not sure that I could because I am not anointed to fill their position. However, I am anointed to do what God has called me to do.

When you are walking in positions that you have not been called to, you will make bad decisions. In position, you must possess the ability to make decisions. When you are anointed for a position, you have the confidence to react with a sense of urgency. However, when you are not, you lack the ability to make sound judgments. When a question is asked, your response may be, "Wait a minute. Let me think about this." But time is of the essence, and you must be able to make an immediate decision. How would you handle this?

We don't understand how the anointing works. We often criticize people holding positions and attack them because we don't recognize their anointing. We must understand it's not the person we are battling with, it's their anointing. Once I have

been called to a position, my anointing is identified by my position and not my flaws. We must learn to give reverence to the position and not battle with the personal flaws of man.

When people are in positions and they carry an anointing from God, they deserve our respect. It's like a mother. She will always be a mother, even if she did not perform well as a parent. The position of mother must be respected as both the person who gave you life and parented you, even when that person does not deserve respect.

Have you ever had a relationship that was controlled by things? I recall a relationship I had with a young lady where we celebrated our birthdays together. One year, she bought me a very nice gift. While I was very appreciative, I knew I had to make it a priority to attend her celebration or her feelings would have been extremely hurt. This is an example of when gifts are given to develop relationship. They bring with them a sense of ownership and unnatural commitment which makes for an unhealthy relationship.

I often refer to this teaching when it comes to relationships. This is one powerful message.

When people do things for you, you may lack the ability to become completely honest with them. When people do personal things for you, you may feel you are obligated to them without the ability to say no.

> *Every man according as he purposeth in his heart, so let him give; not grudgingly, or of necessity: for God loveth a cheerful giver.* (2 Corinthians 9:7, KJV)

Gifts should be presented to those whom God will lead you to without respect of person and with no expectations attached. The Word of God teaches that we should give with an open heart, knowing that we do this because of our obedience to God and not our commitment to people.

My position requires me to submit to God as I commit to others. We cannot allow ourselves to be blinded by things. Things are tangible and can become a distraction. Anyone who sits in the back of the church would know what I am talking about when I say distractions. When you sit in the rear of a facility, you can see so many things. But when you get close to God, you become unaware of the things behind you. That's where we need to be with God, at a place where we don't recognize anything but Him.

Some people do not have the ability to transition from position to person or from person to position, so I must maintain consistency in their lives to keep them from walking away from my life too early. For instance, I can only be pastor to some people because they could not accept anything different from me other than being a pastor.

I must stand and be confident of the position and/or place that I hold in a person's life.

My husband said, "It's amazing how you are with people," and I said, "It doesn't take me long to figure people out." Once I do, I have the ability to place them in their position in my life; then I can just flow with them right where they are. I can't make them me, and I can't make them operate like me. That's important because I need people to be able to receive from all facets of me. If I give them too much at one time, it will make them choke, and if I don't give enough, they'll become malnourished. I have to be at a steady flow where they can digest things and not be overtaken.

Being able to recognize when people can and cannot take what you have to offer is an important balance to learn.

1. Do You Respect People, or Do You Respect Positions? Explain why.

2. Being in a position of leadership, you must possess the ability to make quick and hard decisions under pressure. How would you handle this? What type of decisions are you capable of making under the intense pressure?

3. What has God appointed/anointed you to do?

4. **When speaking of respect for people or positions, you may become controlled by things that stem from what people do. Reflect upon a relationship that was controlled by things.**

26

Can You Be Trusted with Confidential Information?

*But Jonathan Saul's son delighted much in David: and **Jonathan told David**, saying, Saul my father seeketh to kill thee: now therefore, I pray thee, take heed to thyself until the morning, and abide in a secret place, and hide thyself: And I will go out and stand beside my father in the field where thou art, and I will commune with my father of thee; and what I see, that I will tell thee.* (1 Samuel 19:2–3, KJV)

Can you be trusted with confidential information when life depends upon it?

These are the moments you have to reflect and ask yourself if you can hold secrets that are important.

Do you share those things that are volatile?

In having real relationships, you will have to make some hard decisions. To have a really healthy friendship, you have to be wise enough to know what a real secret is. I probably would have been a lot like Jonathan and told David about what Saul was trying to do to him. Fortunately, I am not in that situation, but this is a case where you would have to say what is right and go with your convictions.

What convicts you?

I like the story of Jonathan and David's friendship because it talks about how Jonathan conducted himself as a friend. He went to the two people who were involved, and that would be affected by what he learned. He never talked to his mother, wife, or sister. He didn't include the pastor, the elders, or even the prophet Samuel, who had the ability to give them all clarity.

When things get to a place where you know things aren't right, go to that person directly. Don't bring in other people when you don't have to. The fewer people you involve, the cleaner the situation will be. The more people you put in the situation, the more you have to clean up after the problem is resolved.

And she said unto him, How canst thou say, I love thee, when thine heart is not with me? thou hast mocked me these three times, and hast not told me wherein thy great strength lieth. And it came to pass, when she pressed him daily with her words, and urged him, so that his soul was vexed unto death; That he told her all his heart, and said unto her, There hath not come a razor upon mine head; for I have been a Nazarite unto God from my mother's womb: if I be shaven, then my strength will go from me, and I shall become weak, and be like any other man. And when Delilah saw that he had told her all his heart, she sent and called for the lords of the Philistines, saying, Come up this once, for he hath shewed me all his heart. Then the lords of the Philistines came up unto her, and brought money in their hand. (Judges 16:15–18, KJV)

Could you keep a secret knowing that if you shared it, death would be inevitable?

This is Delilah when she sought to take the strength of Samson. What really bothers me is that she knew the result of her words would be death. In this case, it was actual death, but it could be the death of a relationship, death of finances, or the death of a ministry. Yet in all that, she still was willing to do it.

Delilah went to Samson three times, and on each event, he gave her false information. But what amazes me is, every time she came to him, he told her something, and she brought him evidence that she was going to betray him.

Now there were men lying in wait, abiding with her in the chamber. And she said unto him, The Philistines be upon thee, Samson. And he brake the withs, as a thread of tow is broken when it toucheth the fire. So his strength was not known. (Judges 16:9, KJV)

The Word of God says she went and got the Philistines, and they tried to tie him down until he broke free. She showed him that she was not going to be committed, but yet he still trusted her with his secrets and his heart.

Can you see yourself doing this? We see the relationship is not healthy, and we see that there are people in our lives that are just not going to be good for us. But do we cleanse our lives from them? Sometimes, no.

This type of person should never be in your inner circle because they can't be trusted. We have to know in relationships that not everyone has the right to sit in the secret places of your life. Not everyone should know what could kill you. There are certain things that require a place of secrecy. It is okay for me to show you and teach you my strengths, but my weaknesses should be shielded.

My secret shielding gives me a place where I cannot be violated by flesh. Flesh will deceive you. My weakness can overtake me. My strengths are only as strong as

my weaknesses that are revealed. We all know that when people find out what you have done in your past, it becomes public news, as if it just happened yesterday. Life is meant to be a series of lessons, experienced and taught. Without sharing these moments of strengths and weaknesses, you lose the ability to strengthen your brother or sister when they are weak.

Not everything you go through can be made public. There are some things in my life that God allowed to be time sensitive that I could not reveal for twenty or thirty years after it occurred. When I went through it, I couldn't share it at the time. Not that it was embarrassing, but the situations were still so unstable they could have destroyed people, things, or even myself.

1. Can I Be Trusted with Confidential Information? Explain How.

2. **How do you generally handle confidential information? How do you generally handle volatile information?**

3. How would this change if someone's life depended on it?

4. **What convicts you when you have been untrustworthy to the point where confidentiality was not important to you?**

5. **What would you do when keeping a secret, if shared, death would be inevitable? Can you see yourself sharing what could destroy someone else?**

6. **When you see that a relationship is not healthy because of broken trust, how do you put distance in that relationship?**

7. **How do you cleanse your life from relationships that are not healthy?**

8. How careful are you with whom you allow into your inner circle?

27

What Are You Hiding?

I know most of us are going to say, "I always tell the truth," but you must be honest.

> *The lip of truth shall be established for ever: but a lying tongue is but for a moment.* **Deceit is in the heart of them that imagine evil:** *but to the counsellors of peace is joy. There shall no evil happen to the just: but the wicked shall be filled with mischief.* (Proverbs 12:19–21, KJV)

There are many reasons we may lie. One reason we may lie is to acquire things we cannot get on our own. My mom used to say, "If a man will lie, he will steal, and if he will steal, he'll eventually kill." I used to think her statement was so dramatic and inaccurate, but I eventually found there was a lot of truth in it. I began to see that people who lie are looking for a way to get what they want and will do it by any means necessary.

I do not believe that everyone who sets out to steal from a store intends to commit murder. But in a moment of theft, the situation could lead to them having to defend themselves, and in a moment of desperation, they could commit murder. Therefore lying, stealing, and death are interconnected at times.

Another reason we may lie is to hide things from others that we don't want them to know about ourselves.

Ask yourself, are you strong, or are you weak?

> *Again Esther spake unto Hatach, and gave him commandment unto Mordecai; all the king's servants, and the people of the king's provinces, do know, that whosoever, whether man or woman, shall come unto the king into the inner court, who is not called, there is one law of his to put him to death, except such to whom the king shall hold out the golden sceptre, that he may live: but I have not been called to come in unto the king these thirty days. And they told to Mordecai Esther's words. Then Mordecai commanded to answer Esther, Think*

not with thyself that thou shalt escape in the king's house, more than all the Jews. For if thou altogether holdest thy peace at this time, then shall there enlargement and deliverance arise to the Jews from another place; but thou and thy father's house shall be destroyed: and who knoweth whether thou art come to the kingdom for such a time as this? Then Esther bade them return Mordecai this answer, Go, gather together all the Jews that are present in Shushan, and fast ye for me, and neither eat nor drink three days, night or day: I also and my maidens will fast likewise; and so will **I go in unto the king, which is not according to the law: and if I perish, I perish.** (Esther 4:10–16, KJV)

Esther was a woman who appeared to others as common, but to her family, she was a beautiful daughter of a Jew. She was raised by her uncle Mordecai, and he had commanded her not to tell anyone of her Jewish heritage. When she was a chosen virgin for the king, she gained his favor and was presented gifts to show his love for her. However, when her time came that she needed to reveal her secret to save the lives of her people, she had to make the decision to live or die as revealing her secret could have meant her death. Was she strong enough to handle this assignment?

We often think we are strong until we are tested. We think of ourselves as individuals with the ability to do what others describe as strong, but we ourselves only know what we are capable of handling. We look strong, we look confident, and we look believable; but when tested, many of us fail spiritually because even though we look confident, we are truly weak.

We are weak because we don't understand the purpose of failing. Failure doesn't show we are weak; it identifies where we need to be strengthened. No one is perfect or invincible. You can only gain strength where you have been tested, you have been tried, and you have learned. We are not born strong; strength is developed.

To acquire strength, we must decide to tell the truth no matter the consequences. This may mean we suffer because of our actions. However, not telling the truth could cause others' lives to be perish due to our selfishness. Your decisions are determined by what your conscience can handle.

It takes courage to reveal the truth.

We also lie by omission. It's not that we tell a lie, but we just don't tell the truth in its entirety. This may mean that we avoid answering a question by redirecting the question to another topic. When you can avoid a question by redirecting attention to another matter, this is called deception. I can imagine this is one of the ways Esther was able to keep her secret for so long. She had to be able to steer topics to other things to avoid being found out.

When you have a life filled with lies, it becomes difficult to develop true relationships. When truth becomes clouded with questions and uncertainties, you lose trust.

Relationships are like the foundation of a building; they were designed to be built upon. You develop trust by building relationships. If you don't have honesty, how can you develop the relationship and, in doing so, develop trust? Without trust, you may have a false relationship, only appearing to be real. Why would anyone want to have a relationship with you if you are not willing to be honest?

My story:

I suffered deep emotional scars from my kidnapping. I felt ashamed and uncomfortable with discussing any details of what I had to do to survive. For years I feared walking to school, but I never told anyone. I had thoughts of being followed, and I feared that my abductor would one day return to kill me, but I never told anyone. I developed fears of wooded areas and phobias of big crowds which made it difficult for me to enjoy many outings.

Due to my fear, I couldn't wait to move away from home. I remember moving away with thoughts of never returning to this place of mental horror and fear. After my husband and I were married, I never discussed my kidnapping with him. After being married for four years, we had our first child. She was just what we wanted.

One day I went on an outing and left my daughter home with my husband. Upon my return, I came home, and changed our daughter, and noticed a small amount of discharge in her diaper. I grabbed her and started running out of the door as I screamed obscene words to my husband and I accused him of sexually assaulting our child. When I reached the emergency room, I called for help for my child and for someone to arrest her father. The doctor immediately examined her and pulled me into the room. Alone with the doctor, he said to me, "Please tell me, why do you believe that your husband may have molested your daughter?" I explained to him what I saw in her diaper, and he said, "That was a normal discharge, and no one has touched your child." He asked me, "Are you okay?" I said, "Oh my God! What did I just do? I accused my husband of assaulting our daughter. I could have ruined his life. What is wrong with me?" I felt so bad. After all, we waited years to have a child and he was such an amazing father. But it was my hidden secrets that nearly destroyed him.

When I returned home, he was sitting in the chair with a confused look upon his face. He asked me, "Why would you ever believe that I would do something like this to anyone, especially our daughter?" It was at that moment that I had to tell him what I had been hiding from him.

Unveiling my secret to him helped him to understand the things that at times became big disagreements between us, disagreements such as: why I didn't like having certain people around me; why I did not like attending events with large groups of people; and why I wouldn't allow people to keep our baby. The secret that I was hiding was destroying our marriage, and it was killing me by holding me captive.

1. What Are You Hiding?

2. Define your strengths as a person.

3. Identify and define your weakness.

4. **Why do you think Esther was strong enough to handle her assignment? How would you handle yourself in her crisis?**

5. Do you make decisions determined by what your consciousness can handle? How do you handle yourself in a crisis?

6. Explain how often you hide behind the truth and why.

7. Ask yourself: Am I strong or am I weak? Define why.

8. **Why would anyone desire to have a relationship with you if you are not willing to be honest? What do you offer them?**

9. **Hiding your true identity could affect your relationship with others. If you are not willing to be true and honest, why do you seek relationships?**

28

Are You a Secret Liar Who Shouldn't Be Trusted?

What is a secret liar?

Have you ever met someone who acted as if everything in their life was perfect? Then when you get to know them, you find out nothing they said was true. You have just identified a secret liar. Things look one way on the surface, but their life looks totally different.

> *A lying tongue hateth those that are afflicted by it; and a flattering mouth worketh ruin.* (Proverbs 26:28, KJV)

The Word of God is teaching us that those with a lying tongue hate those they hurt. These people have no regard or care for the lives of the people they afflict. They are just lying to lie and living a life that is not true.

So when asking why people don't like you, could this be a reason to justify their response to you? Can you be trusted? Relationships require trust, respect, and honesty. If you cannot trust enough to be honest with those in your life, then you may be someone who cannot be trusted.

> *But a certain man named Ananias, with Sapphira his wife, sold a possession, and kept back part of the price, his wife also being privy to it, and brought a certain part, and laid it at the apostles' feet. But Peter said, Ananias,* **why hath Satan filled thine heart to lie** *to the Holy Ghost, and to keep back part of the price of the land? While it remained, was it not thine own? and after it was sold, was it not in thine own power? Why hast thou conceived this thing in thine heart? Thou hast not lied unto men, but unto God. And Ananias hearing these words fell down, and gave up the ghost: and great fear came on all them that heard these things.* (Acts 5:1–5, KJV)

How did Ananias and Sapphira lie to the apostle, and why were they killed?

There was a word from the Lord that Peter shared with those who were filled with the Holy Ghost. There was great grace given to them, and they were all blessed with many possessions of lands or houses, and none of them lacked anything. From this group of blessed people, a decision was made that they would sell off their possessions and bring the monies unto the apostle. The money from their sales was to be placed at the feet of the apostle. All monies collected would then be distributed unto every man according to their needs.

But Ananias and Sapphira conspired together and decided to only take a portion of the sale to the apostle and keep for themselves a portion. But it was at the action of their decision that the question was asked, "Why hath Satan filled thine heart to lie to the Holy Ghost, and to keep back part of the price of the land?"

Ananias conspired with Sapphira, and together, they agreed to only do a partial work for the kingdom. They made a conscious decision without persuasion, without influence, but all due to their own insecurities. Their flesh spoke louder than the spirit was speaking to them. They had to convince themselves of what they should keep and how much they would give. The only reason they would have battled with their contribution had to be because God had given them more than they could be trusted with, or they did not believe God needed as much as he asked for.

This was a lie they told themselves that they believed was a secret. But somehow, their secret sin crept into the ears of the apostle, and it was revealed.

How was this secret sin revealed?

There is nothing new upon the earth, and everything done in darkness shall come to the light. God had to reveal their secret sin to make them an example before his people. If they were allowed to get away with this, others would have done the same, causing their new beginning to be born of deception, holding no place for growth in the kingdom. God made them our example.

Don't lie and believe you are greater than the creator of life. God only asks from those whom he has blessed. God gives freely, but we hold on to the blessings of God as if He cannot create them again and again and again.

Like many people, Ananias and Sapphira thought no one would know the lies they only shared with themselves. But God loves us too much to allow us to believe a secret cannot be revealed.

The lies you tell will be seen; some lies have just not yet been revealed.

1. Are You a Secret Liar Who Shouldn't Be Trusted?

2. What is a secret liar? Are you one?

3. Have you ever met someone who acted as if everything in their life was perfect? Explain how that made you feel.

4. **When asking, why people don't like you, could there be a reason to justify their response to you? What are some justifications of why people might not like you?**

5. Can you be trusted? Should you be trusted? Explain.

6. **In Acts chapter 5, how did Ananias and Sapphira lie to the apostle, and why were they killed?**

7. How was this secret sin revealed?

29

How Trustworthy Are You?

*Every word of God is pure: he is a shield unto them that put their
trust in him. Add thou not unto his words, lest he reprove thee, and
thou be found a liar.* (Proverbs 30:5–6, KJV)

God can only use yielded vessels that are willing and able to do what He says without hesitation. God needs us to convince His people that He lives and cares about their needs.

Can God trust you with His Word?

This means that you don't add anything to God's Word and don't take anything out. So those of you who are sharing a prophetic word, I advise you to use God's name carefully and only say what God said. Do not add anything to instructions from God because, as soon as you do, they are no longer His words; they are yours. Anything you add to God's word makes all of it void.

When God gives you insight into someone's world, He does so that He may speak through you and into them. His words are identifiers that connect the receiver to His desired *yes*. When you adjust His words, you alter the meaning of what the instructions would have said. Some people need clear instructions and must hear a specific word in order to move forward. Without it, they may hesitate in moving. After all, God trusted you with His message to be a hidden witness so that He could build faith up in His people.

But **let it be the hidden man of the heart, in that which is not
corruptible**, *even the ornament of a meek and quiet spirit, which
is in the sight of God of great price. For after this manner in the old
time the holy women also, who trusted in God, adorned themselves,
being in subjection unto their own husbands: Even as Sara obeyed
Abraham, calling him lord: whose daughters ye are, as long as ye do
well, and are not afraid with any amazement.* (1 Peter 3:4–6, KJV)

To learn the importance of trust is not always this simple, but when we can be trusted by God, we can be trusted with anything that He gives us. Trust gives you insight to the strength of a true witness. Trust is an honorable thing, but it is not always an easy task. Trust is not what is given to you; it is what you do when someone is watching over you or when you are watching over yourself.

Trust is understanding that you are committed and willing to follow, even though you may have your own thoughts, opinions or views. Nothing is greater than trust in a relationship because all other portions of a relationship are founded under that one word: *trust*.

1. How Trustworthy Are You?

2. Give an example of your unbroken trust.

3. **Can God trust you with His Word? Explain a time you may have added to and/or removed something from God's Word to profit from its meaning.**

4. What will you do with His instructions?

30

Do You View Life as Being Fair?

> *But when the first came, they supposed that they should have received more; and they likewise received every man a penny. And when they had received it, they murmured against the good man of the house, Saying, These last have wrought but one hour, and thou hast made them equal unto us, which have borne the burden and heat of the day. But he answered one of them, and said, Friend, I do thee no wrong: didst not thou agree with me for a penny? Take that thine is, and go thy way: I will give unto this last, even as unto thee.*
> (Matthew 20:10–14, KJV)

Now this is an example of righteous judgment, but once we have set a standard, we will be required to live by it.

The man in this verse was saying he had been committed and did everything that he promised, and only got paid a penny just like those who did less work. He wanted to know how they could be worth the same value to the owner as he was, but he failed to understand that no one is more important than anyone else if the job does not get done. 'Finished' is always better than 'started'. This shows us that life is not fair. Just like it appeared fair to those who received equal pay for less work, it will likewise appear to be fair to the individual who receives what they wanted out of any life circumstance. If you didn't get what you wanted then, to you, it won't be fair. To you, in this situation, "fair" would probably mean receiving a greater portion because you completed a greater percentage of work. But if you are the one that worked the lesser percent, would you still feel it was fair? Or would you feel you'd been paid more than a fair amount?

The Word of God does not teach us life is fair, because God doesn't judge everyone the same. Your convictions may not be mine, nor mine yours; but I have to live life according to how God instructs and convicts me. This is why you have to be able to rightly divide the word of truth so that you do not base your decisions on the word of others.

My story:

When I was seventeen, my dad told me that he would help me purchase my first vehicle if I saved half the cost on my own. I worked really hard, and when I reached my goal, I went to my dad and told him what I saved. He said, "Okay, I will go find a nice little car for you." As you can imagine, it wasn't much, so I shouldn't have expected much, but when Dad came with my car, I was so excited! It was a two-door, lime green Pontiac hatchback. I stood in the back of the house as he pulled up. Dad said, "Get in" and away we drove. I watched him maneuver around as we circled the block.

When we got back to our home, he said, "Okay, now you drive."

With joy, I jumped into the driver's seat, but when I looked on the floor, I saw three pedals and a stick in the console… I don't know why I didn't see it before, but it was a stick shift! "Daddy, I don't know how to drive a stick shift."

"You will learn." He walked me through it and away we went. We were shaking and bucking all around the block. The vehicle was rolling back when I stopped, and it shut off when I forgot to put my foot on the clutch. I was totally out of my element, and by the time we reached home, I said, "Dad can we take it back? I don't know how to drive a stick shift." He said, "No, you will learn." He got out of the car and went into the house. I didn't feel my dad was being fair. I didn't think it was fair that he would make the decision alone of what car I would have since I paid for half of it. I didn't think it was fair that I would be forced to keep something I couldn't operate. I didn't think it was fair that my dad wouldn't even reconsider. Like the workers in the scripture, I murmured and complained after receiving what we had agreed upon. Regardless of my opinion I can't say that my dad's decision was unfair because I gave him permission to make it. It turned out to be a good car. It was reliable, and I was able to teach my friends and siblings how to drive a stick shift.

Our lives may not always seem fair, but we have to remember that when we give someone permission to make decisions, and we agree to their terms. Knowing that their views may not align with ours, but that does not mean they are wrong. Remember to maintain control of your life and make sure you determine what is fair for your life.

1. Do You View Life as Being Fair?

2. What does life being fair look like to you?

3. **With life, there are many lessons to be learned. What's one lesson you saw in this example?**

4. **How would you describe the writer's behavior in the reflective portion of this reading?**

5. **How would you describe my father's behavior toward me concerning this purchase?**

31

How Can You Use Your Privilege to Ensure Equality?

But he that knew not, and did commit things worthy of stripes, shall be beaten with few stripes. For unto whomsoever much is given, of him shall be much required: and to whom men have committed much, of him they will ask the more. (Luke 12:48, KJV)

God makes it clear that he gives more to some than to others but with those resources come responsibilities. A responsibility to live by the Golden Rule: "Do unto others as you would have them do to you." Making decisions with this rule in mind helps to ensure that we consider our positions of privilege when making decisions so they ensure the equality of all.

How do you see equality?

There is neither Jew nor Greek, there is neither bond nor free, there is neither male nor female: for ye are all one in Christ Jesus. (Galatians 3:28, KJV)

According to the Equality and Human Rights Commission, equality is about ensuring that every individual has an equal opportunity to make the most of their lives and talents.

It is also the belief that no one should have fewer chances in life because of the way they were born, where they come from, what they believe, or whether they have a disability.

Equality recognizes that, historically, certain groups of people with protected characteristics, such as race, disability, sex, and sexual orientation, have experienced discrimination.

How do you see privilege?

According to the Oxford English Dictionary, privilege is a special right, advantage, or immunity granted—or available—only to a particular person or group.

One may feel they have special privileges because of who they are, who they are connected to, where they live, what they own, or whom they have the power to control.

In the story below, we have Pharaoh's daughter who found a baby and requested to have one of the Hebrew mothers to nurse him. Now, let's look closely at her request. During this time, the Hebrew mothers were in mourning because the king's decree was to kill all male children at their birth. So, asking a Hebrew mother to nurse this child meant acknowledging they likely recently lost their own so would have the ability to nurse. This was a strong directive but an easy request from one with privilege. Let's read this story and reflect on how you see her request.

> *And when she had opened it, she saw the child: and, behold, the babe wept. And she had compassion on him, and said, This is one of the Hebrews' children. Then said his sister to Pharaoh's daughter, Shall I go and call to thee a nurse of the Hebrew women, that she may nurse the child for thee? And Pharaoh's daughter said to her, Go. And the maid went and called the child's mother. And Pharaoh's daughter said unto her, Take this child away, and nurse it for me, and I will give thee thy wages. And the woman took the child, and nursed it. And the child grew, and she brought him unto Pharaoh's daughter, and he became her son. And she called his name Moses: and she said, Because I drew him out of the water.* (Exodus 2:6–10, KJV)

Privilege here is having the authority to give someone the power to do what you are not capable of doing yourself.

How can you use your privilege to ensure equality?

1. How Can You Use Your Privilege to Ensure Equality?

2. How do you define equality?

3. How do you define privilege?

32

Are You a Person Who Pays Attention When Other People Are Talking to You?

Do you find that you focus on a specific topic that can distract you during a conversation? Something said triggered a thought, and it sent you mentally in search for a response without paying attention to the remaining conversation?

When having a conversation, you don't always have to find a way to fit into it. Are you hearing what is being shared? If you don't, all you are doing is trying to find a place to bring the attention back to yourself.

What kind of person are you?

Do you listen when people are talking?

I counsel a lot of people, and sometimes I find that I am not required to answer. All I really need to do is listen. I had to train myself to listen and not speak when people are talking. I let them talk until they come to a place where there is time for me to respond. I also try to categorize topics within the conversation to be able to answer what's vital to their cause. What I want people to know is that I am listening.

I practice listening so that I can hear what is not being said. If I'm so distracted by trying to find my way into the conversation, I will find myself drifting off mentally.

If you cannot focus on what a person is saying, chances are, you may be selfish. People don't always need your advice; sometimes they just need to scream and have a safe place to vent. It's important to let them know this process is normal, and they will not be judged.

We have to be able to decipher truth.

Some people may talk for hours during a counseling session without ever saying anything of great importance. When God allows the conversation to come to a point of understanding, He will give you what to say.

I practice praying when people are talking with me on serious matters. "Lord, I know you sent them to me. I know you carved this moment out for us, and it was designated in time. I just ask that you give me the words to say when they are ready to receive from me."

Being a trained vessel of God, I have to be careful of what I release into people's lives. I also have to be careful not to make the conversations about me, giving the appearance that my life is perfect. This is why it is very important for you to listen and pay attention to ensure that you are giving wise counsel and good advice.

> *To whom can I speak and give warning? Who will listen to me?* **Their ears are closed so they cannot hear.** *The word of the LORD is offensive to them; they find no pleasure in it.* (Jeremiah 6:10, NIV)

To determine the strength of your listening skills, practice having a conversation with someone without butting in. When you are with that person in conversation, remember, sometimes you don't need to have an answer. Practice sitting silent and listening. Take that moment and see how it helps you in building relationships.

1. Are You a Person Who Pays Attention When Other People Are Talking to You?

2. **Describe the level of attention you give people when they are talking to you.**

3. Do you find that you focus on one specific topic during a conversation? How does that impact the outcome of the conversation?

4. How easy is it for you to become distracted?

5. How do you respond when someone says something in conversation that triggers a memory for you? Do you detach from the conversation, or continue to pay attention?

6. **How confident are you with communication? When having a conversation, do you have to find a way to fit into it in order to become part of the event?**

7. Are you hearing what is being shared?

8. **How do you know when you are truly listening to people when they are talking? How do you adjust when you are not?**

9. **Describe the type of communicator you are.**

10. If you are having a conversation with multiple persons, how do you get fully engaged?

33

What Type of Example Are You Setting?

And they lifted up their voice, and wept again: and Orpah kissed her mother in law; but Ruth clave unto her. And she said, Behold, thy sister in law is gone back unto her people, and unto her gods: return thou after thy sister in law. And **Ruth said, Intreat me not to leave thee,** *[or] to return from following after thee: for whither thou goest, I will go; and where thou lodgest, I will lodge: thy people [shall be] my people, and thy God my God: Where thou diest, will I die, and there will I be buried: the LORD do so to me, and more also, [if ought] but death part thee and me.* (Ruth 1:14–17, KJV)

What if Ruth came from a broken home, where there were no examples set before her? She married and transitioned into Naomi's family. Naomi is a single parent; her husband is deceased. Her sons are now taking on the responsibilities left by their father as they care for their mother. Now, Ruth enters their environment where love and commitment are demonstrated as a family. Her mother-in-law is a fixed attribute in the family. Ruth had to make a choice to embrace her new environment or resist it and allow resentment to come in. Should her husband leave his mother and cleave to her?

What if this were you, could you live with your in-laws and shower them with love?

Somewhere along their journey, Ruth learned how to honor Naomi. She refused to leave Naomi after her husband's death. She experienced something while being married into Naomi's family that taught her how to love, honor, and to cherish their relationship. This experience influenced Ruth to make the decision not to abandon Naomi. She had an "until death do we part" commitment. This was a big commitment, and it came with a real sacrifice. I don't believe Ruth would have made this decision if Naomi was not a true example of a real woman of God. These types of commitment are never made without having a true relationship.

Through life's journey, we learn in our struggles as we develop our strengths. Ruth refused to go back home; she rejected her past and kept her commitment to

Naomi even after the death of her husband. When Naomi made the decision to return back to her country of origin, why didn't Ruth return to her parents as well? She had every right to do so, except the example that Naomi presented to her was so life-changing that she didn't want to live without it.

> *Then* **Naomi her mother in law said unto her, My daughter, shall I not seek rest for thee**, *that it may be well with thee? And now is not Boaz of our kindred, with whose maidens thou wast? Behold, he winnoweth barley to night in the threshing floor. Wash thyself therefore, and anoint thee, and put thy raiment upon thee, and get thee down to the floor: but make not thyself known unto the man, until he shall have done eating and drinking. And it shall be, when he lieth down, that thou shalt mark the place where he shall lie, and thou shalt go in, and uncover his feet, and lay thee down; and he will tell thee what thou shalt do. And she said unto her, All that thou sayest unto me I will do. And she went down unto the floor, and did according to all that her mother in law bade her.* (Ruth 3:1–6, KJV)

Naomi was a woman with great wisdom, and she also had the ability to hear God.

Being a good example for those whom God has placed in your life means you must understand their life is guided by your instructions, so you must pay attention to what you say and use your words carefully.

When leaders are not living their life as a good example, it makes their instructions difficult to trust. Ruth trusted Naomi. The Word states that she did all that her mother-in-law told her to do. Ruth was able to follow Naomi because she lived her life as an open example before her. She was a widow who never remarried and did not have questionable relationships. Naomi was a single parent who raised sons that brought her daughters, who were as committed to her as they were to their husbands. Naomi lived by example; she was trustworthy, and she lived a life without questionable actions.

What type of example do you set when hardship comes?

When you are an example, you must be ready to be used by God regardless of the season of life you are in. We don't know the plans of God. If you can't hear Him, you will miss His instructions which you may need to support your next student. Who knows, this could become the very person who will help to provide for your future.

God had blessings in store for Naomi, but they were hidden under the relationship she had with Ruth. What he placed in their relationship started when they learned to accept one another for who they were. If Naomi had not invested in Ruth,

she would not have stayed. If Ruth was not willing to honor Naomi as her mother-in-law, she might have rejected her and walked away prematurely. Their example should give us the confidence that we can stay and endure to the end. We can make it through the adversities in relationships. We have to accept that we may have hardships with new relationships. There is great wealth in having good examples of committed relationships; and what we do is what will be exemplified by those who will come after us.

Naomi gave Ruth specific instructions. Because she did, these words would guide them into their next destination. Naomi was a real example, and therefore her teachings to Ruth continued into the next generation.

> *So Boaz took Ruth, and she was his wife: and when he went in unto her, the LORD gave her conception, and she bare a son. And the women said unto Naomi, Blessed be the LORD, which hath not left thee this day without a kinsman, that his name may be famous in Israel. And he shall be unto thee a restorer of thy life, and a nourisher of thine old age: for thy daughter in law, which loveth thee, which is better to thee than seven sons, hath born him. And Naomi took the child, and laid it in her bosom, and became nurse unto it.* (Ruth 4:13–16, KJV)

1. What Type of Example Are You Setting?

2. **What if Ruth came from a broken home, where there were no examples set before her, could this be a reason for her not wanting to return home? Explain your reason.**

3. How important is family for you?

4. **Why should Ruth's husband leave his mother and cleave to her?**

5. **Could you live with your in-laws and shower them with love? How would you handle yourself if you were in Ruth's position?**

6. **When Naomi made the decision to return back to her country of origin, why didn't Ruth return to her parents as well?**

7. What type of an example do you set when hardship comes?

8. Who were your examples in life?

34

What Is Your Level of Commitment?

What is commitment? *Webster's* dictionary defines *commitment* as a "pledge to do something in the future to improve conditions today." It's the state or an instance of being obligated or emotionally focused to a charge or trust.

> *Know therefore that the LORD thy God, he is God, the faithful God, which keepeth covenant and mercy with them that love him and keep his commandments to a thousand generations.* (Deuteronomy 7:9, KJV)

Here is my brother's story:

At the age of twenty-eight, my brother fell ill to a traumatic disease in late 1995 and was given a short time to live. He and his son came to stay with me and my family during his illness. He asked me, "Will you please promise me that you won't throw me and my son out when I am too sick to help you?" I responded, "Of course I won't." That was an easy question to answer; after all, I loved my brother, and he was my best friend. So I committed my life to him because I understood there was something that he needed from me, but what I didn't understand was what I would receive from him.

My brother's sickness took a great toll upon my family, especially, with my friends, but nothing else mattered because I was committed to him. During his illness, many people abandoned our lives because they did not approve of my decision to remain committed to my brother. But they were not there when my brother committed his life to everyone that needed him when he had good health. Neither did they understand that my brother needed me. When someone needs you, your commitment must outlast the moment you said yes. Commitment must be strong enough for you to remain faithful to the call until the job is finished.

I will never forget the day of his death. My brother awakened from a comatose state with only the ability to speak to us through eye motion. He responded with one blink for yes and two blinks for no. This was enough for us to effectively communicate with him.

My brother was not a believer in Christ, and all throughout our years together, I witnessed to him about salvation, but he would reject me every time. I was about to learn that it was my commitment to him that allowed him to see and experience the true love of the Lord.

With only his eyes to respond, we asked him, "Would you like to accept Jesus Christ as your personal savior?" He responded with one blink, "*Yes!*" We prayed with him the Sinner's Prayer. When we were finished, he opened his eyes, and he looked at me. He had such a peace that fell over him that I will never ever forget. My brother had finally committed his life to Christ, and I witnessed it!

My brother died that afternoon, and I never left his side. I kept my promise, and I remained faithful. It took my commitment up unto his death to introduce him to God, who gave him peace beyond understanding. While my assignment was hard, I would learn that commitment is something that not only benefits you; it changes the lives of those whom you have been assigned to. Where I thought he needed me, I realized how much I needed him. He taught me so many things that I continue to live by today. He taught me that God is faithful.

> *O love the LORD, all ye his saints: for the LORD preserveth the faithful, and plentifully rewardeth the proud doer. Be of good courage, and he shall strengthen your heart, all ye that hope in the LORD.* (Psalm 31:23–24, KJV)

My husband would often say, "Commitment means remaining faithful long after the feeling you felt when you said yes is gone."

It is so easy to remain committed when you have support. But true commitment is the ability to remain faithful after "hard" arrives. With other people, they will encourage you, and they will push you to get the job done. But what happens to your commitment when it's only you there alone to get the job done?

> *Let your conversation be without covetousness; and be content with such things as ye have: for he hath said, I will never leave thee, nor forsake thee.* (Hebrews 13:5, KJV)

When I think of faithful, the Lord God is a good example of true commitment. His Word declares that he will never leave you or forsake you. Never is a long time and rarely exercised, but to be truly committed, never quitting must be added to the commitment. You should never leave the job half done; it's no excuse to half do anything. You must do unto others what you would have them do unto you. You must never quit when you have been given an assignment from the Lord; you must remain committed. There is something that must be accomplished, and your job is to know

the assignment of God and to understand what He is requiring from you. We often start a good work, but we rarely finish if "hard" arrives.

I ask you to consider the following:

- Can you remain faithful when God is depending solely upon you?
- Why do you quit things so easily?
- Who asked you to do what you started?
- Why did you start when you did?
- What do you expect to achieve when you finish?
- Who will be affected if you quit?

And we know that all things work together for good to them that love God, to them who are the called according to his purpose. (Romans 8:28, KJV)

If all things work together for good to the called, then I must ask, does God get any glory in what you have committed to?

1. What Is Your Level of Commitment with Relationships?

2. How do you define commitment?

3. What happens to your commitment when you're left alone to get the job done?

_____S

4. **How do you remain faithful to God when He is depending solely upon you to get the job done?**

5. What could cause you to easily quit your commitment?

6. **Being committed is important. Does your commitment level determine why you start something?**

7. **Think of your current commitments. Why did you start when you did? Who asked you to start?**

8. What do you expect to achieve when you finish?

9. Who will be affected if you quit?

10. How does God get any glory in what you have committed to?

35

Do You Find Ways to Argue in a Simple Conversation for No Reason?

God had to teach me how to be confrontational because it is a necessary part of my ministry. While I do challenge statements that are not delivered at the appropriate time or place, I am not the type of person who argues over every little comment.

Do you argue without difficulty? Does every little thing people say become offensive to you?

Let's see if you are one of those people who make something innocent confrontational.

Here's the scenario: Someone you know enters a room, and you look at them eye to eye, but upon their approach, they walk right past you without acknowledging you at all. They fall right into a welcoming conversation with the person right behind you.

How do you respond to this situation? Are you offended? Do you begin questioning your relationship with that person? Are you concerned that you may have offended them unknowingly? Do you find yourself getting angry the more that you think about what just occurred?

What are your thoughts?

People will judge you based on how you respond in a crisis. They will listen to your response and how you speak about a person with whom you have a misunderstanding. They will monitor your comments, your body gestures, and the accusations you claim, to determine if you are trustworthy or qualified to be a part of their life. They will determine from your actions and response whether they will develop or terminate a relationship with you.

It is exhausting to explain every comment, gesture, or emotion. People will get tired of defending themselves due to your insecurities. You judge everything that is said when they were only having innocent noncombative conversation.

With that in mind, ask yourself, "What kind of person am I? Am I argumentative? Am I confrontational?"

The hardest thing in ministry is to confront someone or something that could jeopardize the integrity of a ministry. If I had it my way, I would rather not deal with that. But because of where God has placed us as leaders, we cannot allow something to happen without it being addressed. It is our responsibility to maintain the integrity of the church. God is teaching us how to train leaders for the kingdom. This is not an easy position, but it is required to be successful.

How to be confrontational

To be confrontational does not mean you have to cut and wound a person. Confrontation can be very comforting and used as an opportunity for growth and enrichment. If people are walking away totally wounded after a confrontational experience with you, then you are doing something wrong. The goal of confrontation should be to bring about a resolution.

> *This is a faithful saying, and these things* **I will that thou affirm constantly,** *that they which have believed in God might be careful to maintain good works. These things are good and profitable unto men. But avoid foolish questions, and genealogies, and contentions, and strivings about the law; for they are unprofitable and vain. A man that is a heretic after the first and second admonition reject.* (Titus 3:8–10, KJV)

I choose not to argue with foolish people or with people who are under the influence. How far are you planning to get with them? It's like fighting with a toddler. What do you plan on achieving?

1. **Do you find ways to argue in a simple conversation for no reason? What are your goals for your outcome?**

2. **Do you argue without difficulty? Does every little thing people say become offensive to you? How do you respond in these situations?**

3. How easily is it for you to be offended?

4. How often do you question your relationships with people?

5. Do you become concerned that you may have unknowingly offended people you have a relationship with? What causes you to have these insecurities?

6. **Do you find yourself getting angry the more that you think about a situation that occurred? What method can you use to prevent anger from becoming a part of who you have become?**

7. Ask yourself, "What kind of person am I?" Describe who you are today and who you strive to become.

8. **Ask yourself, "Am I argumentative?" "Am I confrontational?" If so, how do you plan on improving these traits?**

9. **How does your disengagement in a simple conversation create an argument?**

36

Do You Point Out People's Errors Publicly?

We don't always know what may be a sensitive subject to others. So I do not recommend that you handle what should be private conversations publicly with anyone unless it is to stop them from destroying someone else in public.

It is hard to know everyone's boundaries, so handling people in public can cause them to shut down and become a wounded victim of your good intentions. The only time I publicly "take care of things" is when I believe a person is trying to make a mockery of someone in front of other people.

For the most part, corrections should always be private. Correction can be received better if it can be carried out in a way that can be explained clearly. If you can adjust it to be tolerable, then the other person can receive it. But if it's done in public, it's probably going to be resented, and you are going to get pushback. People are not going to like what you are doing if they don't know your intentions, especially when you get into higher levels of ministry.

This is a very sensitive topic for women. Women have a hard time being publicly reprimanded. Women hurt very easily, and because they are so easily offended, we have to be careful how we handle them. This is something that we have to be consciously aware of. When you publicly reprimand, it scars deeply. You have to be careful. You have to know people well enough to know what you can get away with and what limits you need to have.

When people are in ministerial positions and they are reprimanded publicly, they won't receive it well because of their status. They may feel their title was disrespected, and in turn, they won't like you for what you have done, even if your intentions were good.

As a result, they may share with people how they feel about how a situation was handled in hopes of defending their reputation. They may stop supporting you, and if you are present at an event, they more than likely won't attend. If you are hosting an event, they probably won't support it. If you are speaking at an event, they may sit silent with no remarks. These are signs of a wounded Christians carrying the gospel of Christ.

Have you ever witnessed a wounded gospel carrier? They became this way because confrontation wounds when it's not handled properly.

1. Do You Point Out People's Errors Publicly?

2. **Have you ever had people publicly point out your errors? How did that make you feel?**

3. **If you publicly pointed out another's error, how did that make that person feel?**

4. **What is a wounded gospel carrier? Have you ever witnessed one? If so, what did you remember most: the carrier that was wounded or the person they wounded by their scars?**

5. Explain your views of their gospel.

37

What Is Your Greatest Attribute as a Person?

Some of us may have a few great attributes, but many of us have one really good one that strengthens us.

What are your greatest attributes?

Here are a few examples of people with great attributes:

Moses in Exodus 3:11–22

One of Moses's greatest attributes was his ability to hear God. The Bible tells us that God was always with him and He talked with him. Because Moses had the ability to hear God, he didn't fear man. With his ability to hear, he learned from the Master and became a great teacher to the children of Israel as he led them out of captivity and into their promise.

Samson in Judges 13:24 to Judges 16:31

One of Samson's greatest attributes was his strength. With his power hidden behind his hair, he was able to do things, and no one could stop him. Samson was confident in his strength and knew where his power lay. As long as he walked with the Lord, he was invincible.

Abigail in 1 Samuel 25:3

One of Abigail's greatest attributes was her understanding. She knew who her God was and trusted Him regardless of how her husband treated her. She didn't fail to protect her country even if it meant making a decision when her husband wouldn't. She followed God's instructions and understood her husband didn't determine the strength of her character; only she could do that.

One of my greatest attributes is that I know how to be a friend. I can support and love. I can commit to those who are going through tough times. I have the ability to commit and value relationships even when we don't always agree.

The other attribute I have to offer is that I am a great teacher. I am a strong and solid teacher of the Word with a message of life. I don't mind sharing my life

experiences or the knowledge that I have learned to help make life easier for others. I know who I am in the Lord, and I am confident in who I have become in spite of my failures and shortcomings. I am not perfect, but I have become a student of His word. I study to show myself approved to be able to rightly divide the word of truth. I study because it is really important for me to know who I am talking about. I don't spend time studying to teach what I have learned; I study to know whom I am teaching about. So when the time comes for me to teach, it is easy to talk about my God, because I know Him.

> *To everything there is a season, and* **a time to every purpose** *under the heavens.* (Ecclesiastes 3:1, KJV)

Knowing who you are and the season you are in does not make you arrogant. It makes you distinct and allows you to be yourself without an excuse.

When you know who you are, you are able to enter a person's life with the expectation that God has ordained this time and this season for you to be there. I don't take it for granted when I am assigned to a person's life because I realize I only have limited time to complete a given task in helping them prepare for life's journey. This also applies to those who have been assigned to help me gain the strength I need to prepare me for my next assignment.

1. What Is Your Greatest Attribute as a Person?

2. List your attributes separately and explain why you chose them.

38

What Is One Great Flaw You Have that You Are Now Committed to Rid Yourself Of?

God shared with me that what He convicts you of must be edited from within. God will send a word to activate an offensive word to you so that He may create change starting from within you. If something about you bothers people and you have become aware of this offense, you need to change. Now that we have completed this teaching series, and you have identified flaws in your character and they convict you, edit them.

Don't ignore the elephant in the room. You must edit the offense in your character. Stop ignoring what you have the ability to change. We talk ourselves out of doing what is good and right for us. God gives us clarity so that we can grow, develop, and mature, but then we talk ourselves out of it. We say to ourselves, "Maybe that's not it. I don't have the issue; they do." But this is not true. If it is an offense to people, edit it out of your life and grow past it!

Start with one offense and begin to edit your behavior with a singular focus to start the process of becoming the "*perfect me.*" Beginning your process will help you identify why some of your relationships have fallen apart.

> *My people are destroyed for lack of knowledge:* **because thou hast rejected knowledge***, I will also reject thee, that thou shalt be no priest to me: seeing thou hast forgotten the law of thy God, I will also forget thy children.* (Hosea 4:6, KJV)

God sends a word to activate an offense and create change in order to bring awareness to who we have become. His Word said we perish for the lack of knowledge, and because we don't have the knowledge of truth, we can't change or grow. We need these hard truths in order to become who He desires us to be.

1. What Is One Great Flaw That You Have That You Are Now Committed to Rid Yourself Of?

2. Describe why you chose your flaw.

3. List any other flaws you are committed to rid yourself of and explain why you are choosing to let them go.

CONCLUSION

He that descended is the same also that ascended up far above all heavens, that he might fill all things. And he gave some, apostles; and some, prophets; and some, evangelists; and some, pastors and teachers; For the perfecting of the saints, for the work of the ministry, for the edifying of the body of Christ. (Ephesians 4:10–12, KJV)

In your journey of becoming the perfect you, you need the Word of God, His apostles, His prophets, His evangelists, His pastors, and His teachers for the perfecting of you. When God is ready for us to be strengthened with wisdom, prepare for offensive words. The Word of God can be very offensive, like a double-edged sword, because it was produced to create change.

In this segment from the series Becoming the Perfect Me, hopefully you have started the process of knowing who you are from the inside out. The overall intention is to reveal to you real reasons why people may not like you. You may have wrestled with the discovery of knowing why people don't like you, but hopefully, you have started the process of becoming the perfect *you*.

This has been an in-depth study on an internal discovery.
I hope it really ministered to you.
I also hope it revealed something to you that was once hidden.
I hope it helped you become a better you.

ABOUT THE AUTHOR

W alking in Purpose

Theresa A. Roberts was born and raised in Chicago, Illinois. Theresa is the eighth of twelve children born to Mr. and Mrs. Kinzy Greenleaf. She married Randy Roberts in 1985 and together they have three daughters: Ashley, Megan, and Chelsea.

Theresa holds an AAS degree in Computer Information Services and a BA in Computer Business Management. She utilized her experience as a Telephony Support Analyst for municipal governments for over 23 years.

Theresa made Beaufort her home after her husband was stationed at MCAS Beaufort while serving in the US Marine Corps. The couple served together in ministry for many years before being led to found Love House Ministries in 2001. Love House Ministries is an outreach ministry in Beaufort, South Carolina comprised of a small body of believers with like minds, serving to meet the needs of the community. Theresa serves as the Senior Pastor under Apostle Randy Roberts. Their ministry has continually evolved to meet the needs of their community. Pastor Theresa affirms that she did not choose this direction of ministry, but that it was chosen for her by God.

Love House Ministries' mission statement targets three areas of life:

Racism: To create a bridge over the racial waters separating the body of Christ. (John 4:21–24)

Divorce: To halt the decay of marriages by driving out the spirit of divorce. (1 Corinthians 13:3–7)

Oppression: To bring good news to the oppressed and the brokenhearted. (Isaiah 61:1–3)

Theresa's journey and experiences as a child, a wife, and a mother have all assisted in the formation and execution of her purpose and passion. At the age of 10 while walking to school, she was kidnapped and held captive by a pedophile. This event was life changing for her, but the ministry of caring for and serving women, children, and families helped her heal with purpose.

Her survival inspired her to start the $1.00-A-Day After School Program to create a safe environment for children after school to prevent any child from being physically hurt, sexually abused, or abandoned. This program was designed to reduce financial burdens for families not able to afford childcare, offering the option for parents to volunteer time in order to reduce or eliminate their childcare costs. Being a woman in any business can be difficult, but when your business is ministry, and one that is dear to your heart, that makes things a whole lot easier.

In 2015, Theresa was appointed by Governor Nikki Haley to the Domestic Violence Task Force for South Carolina, and that same year Love House Learning Academy (LHLA) was granted nine locations (facilities) by Beaufort County allowing for the expansion of the program that had been in existence since 2009. The LHLA motto is "Teach them what we know, and they will become what they learn."

Thanks to Theresa and Randy's influence within the community through Love House Ministries and Love House Learning Academy they are able to sponsor many community outreach programs such as:

The Community Bowling Center & Laser Tag Arena, $1.00-A-Day Aftercare, Summer Learning Center, Senior Day Program and a Senior Feeding Program. They are also able to support community events such as: free oil changes, Weekend to Remember, Everyone Counts, Operation Holiday Heroes, and The Giving, just to name a few.

Theresa is excited to be able to share what the Lord has given her through her book *Why Don't People Like Me?*, which is the first in a series titled *Becoming the Perfect Me*. The series is an expansion of her women's bible study, in which Theresa taught on who she was, what she survived, and how to allow pain to help develop

your purpose. This series is designed to help women define their strengths and weaknesses from the inside out.

To learn more about the community outreaches that Love House Ministries currently have in place or to find out how you can support these outreach programs, visit their websites at www.lovehouseministries.org and www.TheresaARoberts.com.

CPSIA information can be obtained
at www.ICGtesting.com
Printed in the USA
LVHW050756280821
696314LV00001B/1